MW00824888

HAPPY Birthday Angel!

... "Out of all The Peoples on the face of the earth. the Lord has chosen You to be His treasured possession."
Deuteronomy 14:2 (NIV)

♡ You are His child. You are so so precious!

♡ You are worth every sacrifice He has made!

♡ You are a heavenly treasure!

♡ You are a Angel Among Us!

I Love You!

Tonya
8·10·2023

PRESENTED TO:

My Angel Barbara

FROM:

Tonya

DATE:

August 10. 2023

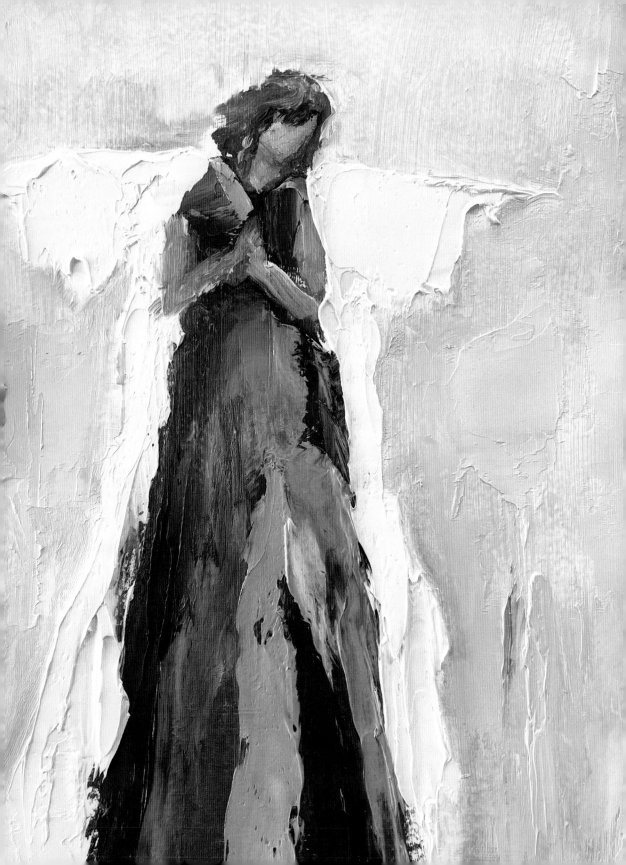

Endorsements

"Through her unique artistry, and now through her words, Anne Neilson reminds us of God's gift of angels. Her delightful stories encourage us to 'remember to welcome strangers, because in doing so [we] may entertain angels unaware.'"
 —Max Lucado, pastor and bestselling author

"Anne Neilson's new book, *Entertaining Angels*, is a wonderful reminder to me of how blessed I've been in my life to have angels watching over me. Open your heart and eyes to God's heavenly gift."
 —Moll Anderson, author, home and lifestyle expert

"My friend Anne Neilson is such a talented and beautiful person. In her new book, *Entertaining Angels*, Anne uses a garden of color and profoundly tender words to share the immeasurable love God has for each of us. When we are searching for strength and divine direction, we can rest in this promise: our Shepherd knows where to find us."
 —Sheila Walsh, television host, author, and Bible teacher

"I love this book. Through these pages of stories, I was inspired to choose to see things differently. My heart was stirring as I hung on to every word and realized that God, no doubt, has set up some very specific moments in our lives that can change, save, heal, and restore if we dare to entertain them."
 —Tammy Trent, author of *Learning to Breathe Again*

"If beauty and art are the standards by which you look for devotionals, this one is exquisite. Beyond beauty and art, however, *Entertaining Angels* is filled with authentic stories and sacred sentiment that will challenge, charge, and change you. It's a reflective and stunning compilation of inspiration. You need to own this!"
 —Gwen Smith, host of the *Graceologie* podcast, speaker, coach, and author

ANNE NEILSON

Entertaining Angels

True Stories and Art
Inspired by Divine Encounters

Foreword by Roma Downey

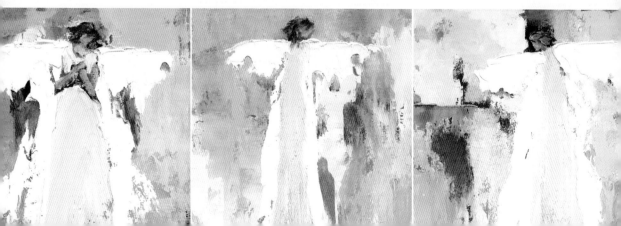

Entertaining Angels

© 2022 by Anne Neilson

All rights reserved. No portion of this book may be reproduced, stored in a retrieval system, or transmitted in any form or by any means—electronic, mechanical, photocopy, recording, scanning, or other—except for brief quotations in critical reviews or articles, without the prior written permission of the publisher.

Published in Nashville, Tennessee, by Thomas Nelson. Thomas Nelson is a registered trademark of HarperCollins Christian Publishing, Inc.

Thomas Nelson titles may be purchased in bulk for educational, business, fund-raising, or sales promotional use. For information, please email SpecialMarkets@ThomasNelson.com.

Unless otherwise noted, Scripture quotations are taken from the Holy Bible, New International Version®, NIV®. Copyright © 1973, 1978, 1984, 2011 by Biblica, Inc.® Used by permission of Zondervan. All rights reserved worldwide. www.zondervan.com. The "NIV" and "New International Version" are trademarks registered in the United States Patent and Trademark Office by Biblica, Inc.®

Scripture quotations marked ESV are taken from the ESV® Bible (The Holy Bible, English Standard Version®). Copyright © 2001 by Crossway, a publishing ministry of Good News Publishers. Used by permission. All rights reserved.

Scripture quotations marked KJV are taken from the King James Version. Public domain.

Scripture quotations marked MSG are taken from THE MESSAGE. Copyright © 1993, 2002, 2018 by Eugene H. Peterson. Used by permission of NavPress. All rights reserved. Represented by Tyndale House Publishers, a Division of Tyndale House Ministries.

Scripture quotations marked NASB are taken from the New American Standard Bible® (NASB). Copyright © 1960, 1962, 1963, 1968, 1971, 1972, 1973, 1975, 1977, 1995, 2020 by The Lockman Foundation. Used by permission. www.Lockman.org

Scripture quotations marked NKJV are taken from the New King James Version®. © 1982 by Thomas Nelson. Used by permission. All rights reserved.

Scripture quotations marked NLT are taken from the Holy Bible, New Living Translation. Copyright © 1996, 2004, 2015 by Tyndale House Foundation. Used by permission of Tyndale House Ministries, Carol Stream, Illinois, 60188. All rights reserved.

Any internet addresses, phone numbers, or company or product information printed in this book are offered as a resource and are not intended in any way to be or to imply an endorsement by Thomas Nelson, nor does Thomas Nelson vouch for the existence, content, or services of these sites, phone numbers, companies, or products beyond the life of this book.

Art direction: Sabryna Lugge
Interior design: Mallory Collins

ISBN 978-1-4002-3576-6 (audiobook)
ISBN 978-1-4002-3575-9 (eBook)
ISBN 978-1-4002-3573-5 (HC)

Printed in China

22 23 24 25 26 DSC 10 9 8 7 6 5 4 3 2 1

This book is dedicated to you—yes, you!
I pray as you hold this book, read this book, share this
book, you will be encouraged by these inspiring stories.
I pray that your eyes will be opened to the possibilities of knowing
that every day we have the opportunity to entertain angels.

Do not forget to show hospitality to strangers, for by so doing
some people have shown hospitality to angels without knowing it.

HEBREWS 13:2

Contents

Foreword

*D*ear friends,

 I am honored to write the foreword for this beautiful work of art, *Entertaining Angels.* Anne Neilson is not only a dear friend of mine but an artist I truly admire as well. She is an inspiration to those around her, and Anne's artwork has blessed my life in many ways. I have several of her angel oil paintings anchored on the walls at my home in Malibu, California, and each time I pass them, I feel protected and grateful for the divine reminders of God's messengers.

 As we all know, life presents ups and downs, highs and lows, sunrises and sunsets, and at times it can feel like the darkness overcomes. I have found, even in my most grief-filled days, that focusing on the mighty power of God will never lead us astray, and that's exactly what *Entertaining Angels* will help you do. This book is laced with stories of God's goodness made visible through His actions that then fill us with hope. He is our light, He shines through the darkness, and He is always moving and working on our behalf; yet it's so easy to forget because . . . well . . . there is just so much we do not see!

 There have been many times in my life where I was just about certain I entertained angels. Looking back, the most obvious signs of encountering angels for me were the moments filled with pure kindness: a warm smile that touched my heart, an encouraging word, or a compliment from a stranger. Our mighty Creator delights in kindness. These interactions, these moments of compassion, have acted as powerful testimonies in my life and have inspired me to then move, act, and live in kindness.

One of the greatest signs of God is the tenderness that flows from a pure heart. My hope is that as you sit with this book it helps open your eyes to the moments in your life where you have encountered the divine. Meditating on these times will fill you with enough hope to make it through the day.

The beautiful stories Anne shares in this book act as powerful reminders—that the mighty angels in the heavenly realms are here among us in our daily lives, and they are appointed by a faithful and truly good God. On behalf of Anne I invite you to come along this journey with us and reflect on the ways you might have entertained angels. After all, our Savior and Guide is always by our side, and since the beginning of time He has been known to send His angels down to earth, especially when we need them the most.

I pray *Entertaining Angels* blesses you in every way and every day. May the wind be always at your back and the mighty angels by your side . . . until we meet again, my dear friends. Sending all my love and light to you and yours. God bless.

Sincerely,
Roma Downey
Actress in *Touched by an Angel*,
producer, and author

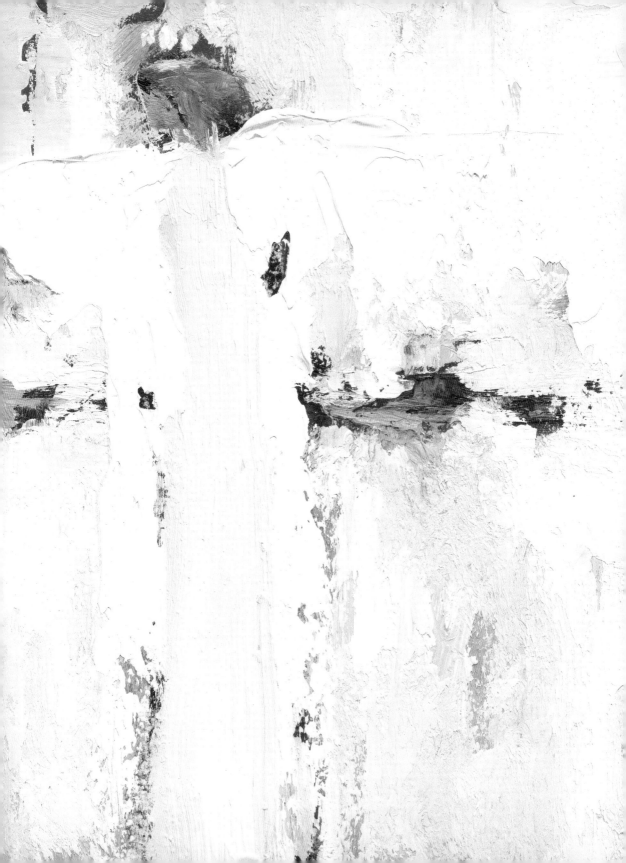

Introduction

Do not forget to show hospitality to strangers, for by so doing some people have shown hospitality to angels without knowing it.

HEBREWS 13:2

*W*ow. As I sit here reflecting on all that God has done—immeasurably more than I could ever ask or imagine—I am overwhelmed, or as I like to say, *whelmed over*, with awe of how God continues to move and work in our lives during the midst of chaos, uncertainty, loss, sadness, and joy. And just like I discover in His Word: He meets us in the lowest valleys and on the highest mountaintops. I've been to both places many times. He remains faithful, steadfast, true, and sovereign. To God be the glory for all things.

My last devotional book, *Anne Neilson's Angels: Devotions and Art to Encourage, Refresh, and Inspire*, was on words and art—words to encourage, art to inspire, and devotions to refresh you on the journey of life. This book is more about action—stories of how we see God move in the midst of our busy lives. Stories of how we can be an angel in someone's life when they are struggling or even rejoicing. Stories of how someone might be an angel in our life—or just downright unexplainable stories of entertaining angels.

Have you ever had one of those experiences, a moment after an encounter, that just left you in a state of wonder? Throughout these stories, my hope is that you would be stretched to open your eyes to those experiences or that you would become the angel in someone else's life for that moment.

Today, our entire world—the world that God so loved that He gave His only Son to die for us (John 3:16), the world that spans far and wide, the world that wants to shut out the mysteries of God—needs love. Our world needs grace. Our world needs to be surrounded with "angels" on earth, as we each bring hope through our actions.

In my many years of painting angels, I am asked often, "Do *you* see angels?" I don't believe I have ever seen an actual angel. But as I paint, while listening to praise music and allowing the Holy Spirit to flow through my spirit and out onto the canvas, I believe God creates these ethereal beings on my canvas. I'd like to say that just like there are no two snowflakes alike, nor two fingerprints, there are no two angel wings that I have painted in more than two decades that are alike.

My best friend, Jane, who went home to Jesus in June 2019, was involved in a powerful prayer group that would meet every week. During these prayer sessions there was one girl who would actually *see* angels. She described the angels in great depth and wonder. Jane was desperate to *see* an angel. Every week she would pray that God would give her the gift to see an angel, and every week she would return home disappointed.

One day as she was driving to her prayer meeting, she told the Lord, "Okay, if I'm not going to be able to see an angel, I pray that my guardian angel will be equipped with the armor of God—helmet, sword, and all." She kept the prayer to herself and quietly stepped into the prayer meeting. A few minutes later the prayer warrior who *saw* angels burst out laughing, "Jane! Your angel is decked out in full armor and has the largest sword I have ever seen gleaming over you!"

Angels are woven into the fabric of our lives. Seen or unseen, they are real. And just as Jane prayed, angels are equipped. They have a mission.

We humans are not angels, nor is it biblically correct that when we die we

become an angel. But God created us, just as He created the angels, with a mission. We have been placed on this earth to be the hands and feet of Christ. We are called to be "angels" to our world.

I love the story Jesus shares in Matthew 25:35–40:

"'For I was hungry and you gave me something to eat, I was thirsty and you gave me something to drink, I was a stranger and you invited me in, I needed clothes and you clothed me, I was sick and you looked after me, I was in prison and you came to visit me.'

"Then the righteous will answer him, 'Lord, when did we see you hungry and feed you, or thirsty and give you something to drink? When did we see you a stranger and invite you in, or needing clothes and clothe you? When did we see you sick or in prison and go to visit you?'

"The King will reply, 'Truly I tell you, whatever you did for one of the least of these brothers and sisters of mine, you did for me.'"

Dig deep into your spirit to see how God is guiding you to be an angel in someone's life. This might just mean wrapping your arms around someone who grieves. Or being the hands and feet of Jesus, bringing comfort and peace to a world so torn and divided. Or simply reaching out more in love or kindness.

I invite you to come along this journey with me as we discover all the different ways we entertain angels. In the stories that follow you will hear all kinds of random acts of kindness. Most of these stories are from my personal journey, but some are from friends who had eyes to see. Be encouraged, surrender your hearts, open your eyes, and take hold of God's mighty hand as He guides you along the journey of life. In a world where brokenness, division, and darkness are rampant, we need more light and angel interactions. Whether you have seen angels, had a supernatural encounter with an angel, or acted like an angel in someone's life, to God be the glory as He equips you to show kindness and love.

BLESSINGS,
ANNE

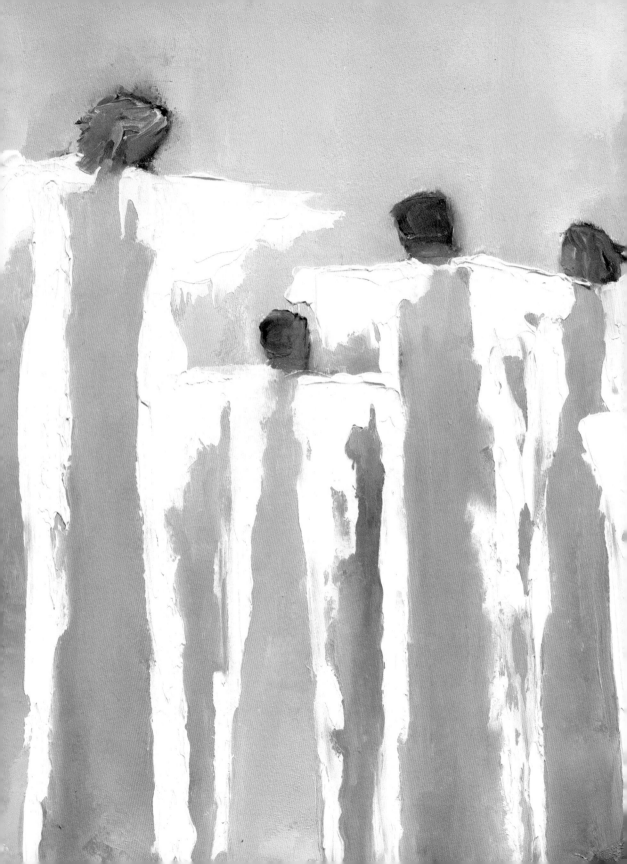

A Visitor in My Studio

Soon the house where he was staying was so packed
with visitors that there was no more room.

Mark 2:2 NLT

By Anne Neilson

Over the course of painting for twenty years, I've often been asked why I paint angels. I paint angels because I want to create something that reflects my faith. I believe in angels, and I believe that God places not only guardian angels but also a host of angels around us. (I have grown to pray not just for a guardian angel for each of my children but for a whole host of warring angels to surround them and protect them all the days of their lives!)

Early on in my painting career—and a few months after my first book *Angels in Our Midst* was released—a young woman strolled into my studio. Kate, we'll call her, appeared to be in her thirties or forties and had just moved to Charlotte, North Carolina, in search of a new home. She had a story to share and was eager to tell it. As I welcomed her into my messy studio filled with angel paintings and splatters of wet paint seemingly everywhere, she shared about a time when she was being prepped for surgery. One of the nurses had

looked at her and said, "Wow, there are a lot of angels in this room!" She then slipped under anesthesia.

Later, when she woke up, Kate remembered the nurse's comment and mentioned it to her mother. Her mother then went into detail about when Kate was born. As they were leaving the hospital, she made a stop at the little chapel and prayed that God would surround her daughter with His angels. Tears streamed down Kate's face as she heard this story of her own birth. Kate tucked away that message and went about her life.

Several years later, moving to a new city and looking for a new home in Charlotte, Kate was touring a lovely house. As the realtor showed her around, a seven-year-old girl who lived in the house sat at the kitchen table drawing. Kate was getting ready to leave, and just as she was saying her goodbyes, the girl ran to her and gave her the drawing she had been working on. Amazed, Kate looked at the paper and then at the girl. The girl had drawn a stick figure of a person in the center of the page with angels all around. On the top of the page, she had written, "I see angels surrounding you."

There in my studio Kate pulled out the drawing to show me as tears filled both our eyes. *Wow, oh wow*, is all I could think. I paint angels almost every day, and yet this simple drawing struck me deep in my soul.

Throughout Kate's life God used a simple but powerful prayer from her mother over her as a newborn—that God would surround her with angels. Years later, a comment from a nurse in an operating room, and then a drawing from a little child, would continue to convey His powerful message: *I see.*

Sometimes we forget that we serve a God who sees everything about us. He sees our pains, our joys, our failures, and our successes. He sees, and He will go before us today and always. Don't just pray for a guardian angel; pray for a host of warring angels around each and every situation in life, over your children, over your marriage, over your job and the people you serve.

God places
not only
guardian
angels but
also a host
of angels
around us.

2

From Beyond the Grave

*Let your speech always be gracious, seasoned with salt, so
that you may know how you ought to answer each person.*

COLOSSIANS 4:6 ESV

*By Tracy Kornet, Emmy Award–winning writer, host, and journalist
who anchors the evening news at WSMV4 in Nashville*

I walked to the mailbox and was stunned to see a letter from my friend Mary
Kay. She effusively shared her thanks for my friendship and my validation
of what she had to offer this world. She mentioned our Bible study time together
and how chatting with her in group exercise classes helped her lose a life-changing
two-hundred-plus pounds.

Mary Kay would never have known that just hours after mailing that thank-you
note to me, she would be gone.

Earlier that morning, before my trip to the mailbox, a family member had texted
the shocking news: Mary Kay had died of a heart attack in the middle of the night.
I was literally reading a letter from beyond the grave, and I felt the Holy Spirit's
presence all over it.

Life hadn't been kind to Mary Kay during her thirtysomething years. She was

angry, deeply lonely, addicted to painkillers, on disability, and she felt rejected by the world, especially by men.

I first met Mary Kay when we both signed up to serve at our North Texas church. We were attending a training for Keeping Kids Safe—a program that teaches people who work with children how to build safeguards and recognize the warning signs of potential predators within the church. The group was compelled to "be the change that you wish to see in the world." It seemed, however, that bad things had happened to Mary Kay—and the scarring showed in her attitude.

A NOTE FROM ANNE: I received a message from Tracy Kornet that if I were ever in Nashville, Tennessee, she'd love to meet for coffee. Turns out I was heading there within the week, so we set up a coffee date. Our time was limited, but our conversations were rich with God's glory and how He was working in and through our lives. Tracy became an instant friend and angel in my life.

I reacted to her grumpiness with compliments and love throughout a forty-five-minute, packed-with-women minivan ride to Fort Worth, publicly acknowledging her obvious intelligence and willingness to serve others.

Months later I found myself teaching the sexual abuse prevention course alongside Mary Kay, trying to help with pacing and engagement, encouraging her along the way. As we got to know each other, I invited her to various Catholic-Protestant women's Bible studies, welcoming her in to a caring, vibrant circle of friends. Mary Kay told me her parents would be attending her niece's baptism, for whom she was the godmother. I offered to attend and support her, meet her parents, and simply be a friend.

In her letter Mary Kay shared that my showing up to that baptism had meant the world, proving to her father she was worthy of a friend.

Wow. Sometimes we can't imagine how far a simple action might go. It can re-chart a life course. Speak life into a dream. Our words and actions have power.

Proverbs 15:4 tells us, "Gentle words are a tree of life; a deceitful tongue crushes the spirit" (NLT). And Colossians 4:6 (ESV) says, "Let your speech always be gracious, seasoned with salt, so that you may know how you ought to answer each person."

I'm no angel, but I do believe if we obey the promptings of the Holy Spirit, we can serve as such. As Christians we are called to be the hands and feet of Jesus. But it takes tuning in—reading Scripture and reflecting on His Word—to hear His voice. And it doesn't stop there. Once we hear that voice, that whisper, and feel that nudge, we must obey and *act.*

Who in your circle of work colleagues, carpool moms, yoga classes, and dance dads is in need of an encouraging word? An invitation to coffee? A meaningful conversation where he or she is actually heard?

Is there a real-life angel in your life to whom you might want to send a thank-you note? Someone who called after a miscarriage, cleaned your house out of the blue, supported you through rehab?

May we all respond to the promptings of the Holy Spirit and act as an angel. May we open our eyes and see the angels we entertain.

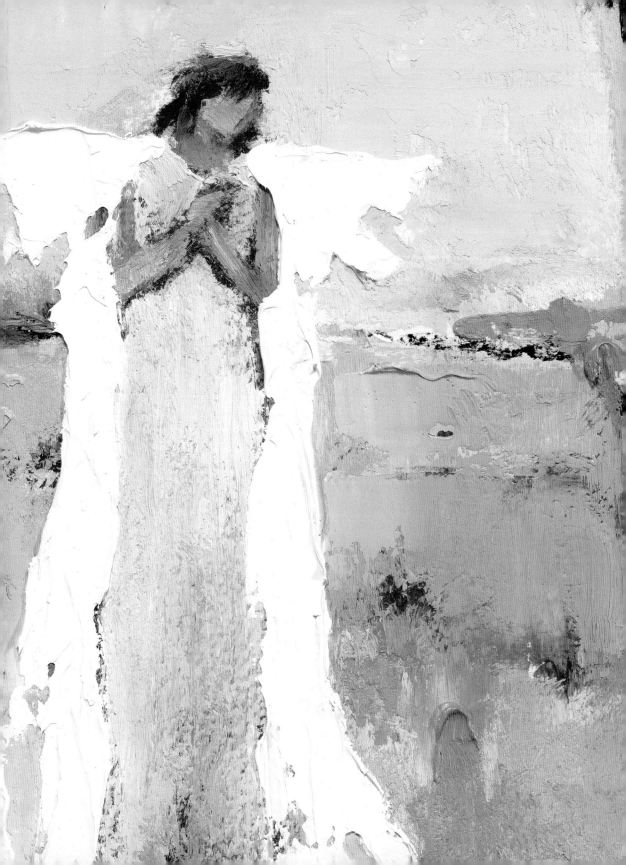

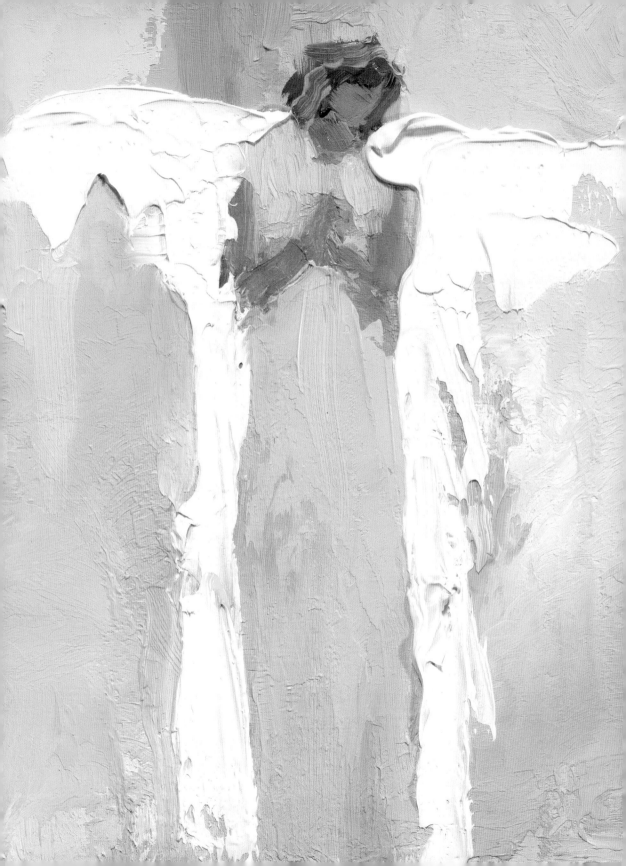

3

A Seat Beside Me

You have searched me, LORD, and you know me.

PSALM 139:1

By Anne Neilson

My family and I were headed home from our yearly summer trip in the Bahamas. It was a much-dreaded day, and we hated leaving the clear, turquoise waters and wished we could bypass the two returning flights. But instead we rallied, packed, and began our journey back to Charlotte, North Carolina.

The first flight was easy and direct to Miami. But then, unfortunately, we had a long, five-hour layover, and by this time we all just wanted to be home. Finally we boarded our plane. We got settled and sat . . . and sat . . . and sat. In fact, we sat on the tarmac for more than an hour . . . and then another hour . . . going nowhere. The pilot finally announced that we needed to change planes. This happened to be our last flight home, but there were other passengers who had connections and would definitely need to find other ways to get to their destinations.

We deplaned and walked what felt like miles to the next gate, where we waited a long time to board again. I finally got settled in my new seat. The two seats next to me were empty, so I texted my family, who were now scattered throughout the

plane, and announced that once boarding was complete someone could come sit with me.

About twenty minutes later boarding still was not complete, though we were assured by the crew that we would be taking off shortly. A few minutes after that announcement, a single mom came stumbling onto the plane with her two sons—a three-year-old and a one-month-old—and plopped down beside me.

Now, if you've read my other devotional, you'll know that I do not have the personality to just start chatting with my seatmates on airplanes. Instead, I send out vibes like a neon sign flashing "Do not disturb."

It's also worth mentioning here that just the night before we left the Bahamas, I had had a conversation with my family about wanting to be a grandmother. There, I said it. I want grandbabies—in God's timing, of course.

So something in me just melted seeing this frazzled mom caring for her two precious babies as we sat on the plane, again for hours—not budging. This mom tried her best to manage and entertain her two restless little ones, and then her three-year-old had to use the potty.

With grandbabies on my brain, I leaned over and asked if it would help if I held her baby while she took her toddler to the restroom. She eagerly took me up on my offer and shoved her precious baby boy in my arms. When she came back we began talking.

Her name was Ashley, and she opened up about her life, sharing that she was a single mom and that Noah, her eldest, had a different dad. She desperately wanted to be a good mom, and as I looked at this beautiful young mother, I said, "Oh my gosh, you are already a great mom! You chose to say *yes* to having Noah." She shared that she was a new Christian when she got pregnant, and when she went to the clinic, some ladies there prayed for her. She hadn't felt that much love in a long time, and

when she went home she opened the Bible, read the story about Noah's ark, and knew that would be her son's name.

Our flight finally took off around 10:00 P.M. It had been a long day that turned into a long night, complete with hungry, crying babies. I just wanted to wrap my arms around this precious young mama and encourage her. I told her that God sees her. He has a plan for her.

Besides encouraging Ashley, the best part of the trip was that I got my baby fix. I got to hold this precious baby, feed him, change him, and comfort him as I walked him up and down the aisle to quiet his cries—and of course give my kids a wink or two, letting them know that one day I want one!

As we landed around 1:00 A.M., I carried little Gavin off, following his mom and big brother. We were weary, exhausted from traveling, but still somehow in good spirits. Ashley and I shared a moment of gratitude for each other, and we continue to stay in touch. She sometimes shares news about her boys—like when she had both of them baptized.

Ashley, who is a great mama, might tell you that I was her angel that night, coming alongside to help her in a time of need. But really, I feel like she was sent to me by God, who knows the deepest desires of my heart—in this case to be a grandma and have my house full of babies again—and I believe she was a messenger sent to let me know He sees me, hears me, and knows me. Our God is so mighty and loving that He can orchestrate the most divine opportunities for multiple parties at once, and when we least expect them.

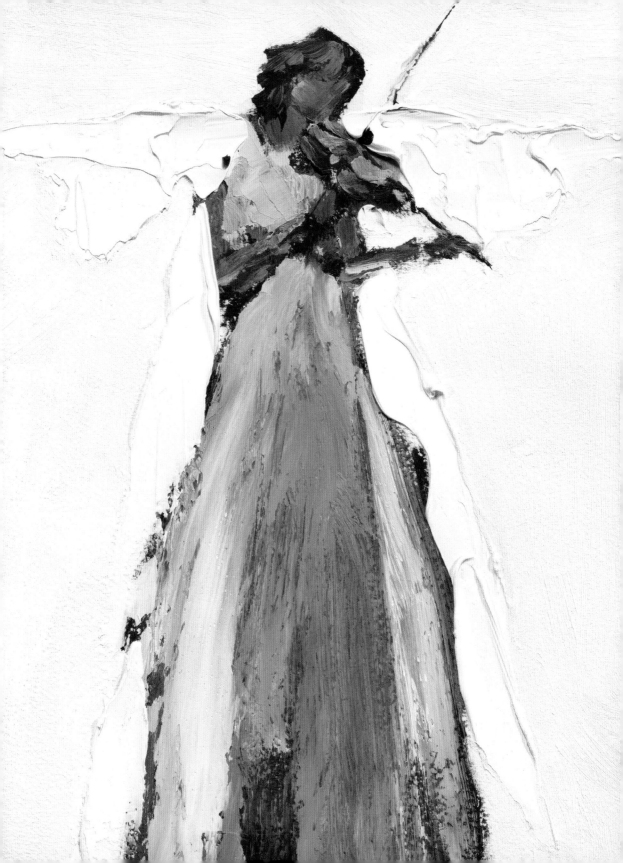

4

An Angel Who Could No Longer Fly

The eyes of the LORD are everywhere.

PROVERBS 15:3

By Ron Hall, art dealer, author, and producer

ave you ever seen an angel? Not sure? Well, it's quite likely you have but did not recognize it as such because of its hidden or soiled wings. Perhaps you encountered one that was flying too close to the ground. My friend Denver greatly influenced my angel radar, for which I'm eternally grateful.

More than twenty years ago, when I first felt a conviction to share my financial blessings, I was walking the streets of Fort Worth, Texas, with my homeless friend Denver. I had an idea that day to stop by the bank and get one hundred dollar bills and pass them out to the homeless people we encountered on our walk. Near the end of the day, we saw a homeless man who appeared to be way too intoxicated to stand. I approached him as Denver stood and watched.

"May I help you?" I asked.

"A few dollars would be nice," the man said with slurred words.

A NOTE FROM ANNE: Have you read the book *Same Kind of Different As Me?* If not, grab a copy and some tissues. It's the powerful story of Ron Hall, an international art dealer, and Denver Moore, a man experiencing homelessness. You'll read more about our connection in chapter 5. Ron has been an angel in my life since 2009. His heart and passion for people run deep. Enjoy this snapshot of an angel who could no longer fly.

I reached into my pocket and realized I had gone through all the one-dollar bills. I saw a twenty-dollar bill and quickly stuffed it back in my pocket.

"Give the man the twenty," Denver scolded. I wasn't aware he had seen my sleight-of-hand trick.

"I don't want to get him even drunker," I shot back, slightly annoyed.

"Mr. Ron, it's your business to bless him, and it's between him and God what he does with it."

I pulled the twenty back out of my pocket and blessed him as we walked away.

When we reached the corner, Denver grabbed my shoulder and spun me around until our faces were inches apart. "Mr. Ron, that man you just judged is named José. He don't drink and he don't do no drugs—never has. José was the hardest-working man on the streets, working seven days a week as a brick and stone layer. He chose to be homeless and eat all his meals at the mission so he could send every penny he made back to Mexico to take care of his large family. For a long time the man's been a lotta people's angel before he had a stroke and can't fly no more—can't even get back to Mexico."

Denver pointed and said, "Mr. Ron, look down the street and tell me what you see."

Several blocks away the street ended at a large, imposing historic courthouse.

"I see the courthouse," I replied.

"You sure do, and let me tell you that the courthouse is full of judges and God

don't need no more of them; God needs servants. So if you gonna walk these streets with me, you leave your judge's robe in your closet and come as a servant. Did you hear what I just said?"

I nodded.

Then Denver told me, "We never know whose eyes God is watching us out of, and I just saw you through the eyes of someone's angel who could no longer fly."

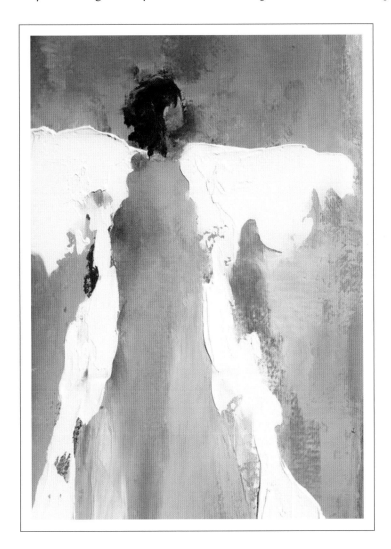

5

In the Streets of New York City

The Lord is my shepherd, I lack nothing.

Psalm 23:1

By Anne Neilson

In the previous chapter you met my friend Ron. We became dear friends after I read his book *Same Kind of Different As Me.*

One day several years ago, my husband, Clark, and I were leaving for a wedding in Charlottesville, Virginia. Before we left our house, a friend dropped by and said, "You have to read this book!" I had known about Ron (the international art dealer) and Denver (the homeless man), and I was eager to read their story. Several of my friends had said it was such a profound story that had changed the hearts of many.

So on the car ride home, I opened the book and started reading. About twenty minutes into the trip, my husband finally said, "Are you not going to talk to me? We have a five-hour trip home!"

I told him the book was so compelling, I couldn't put it down!

"Well, then, read it out loud," he said.

For the next four and a half hours, I became a human audiobook, reading aloud the story of a famous art dealer and a homeless man. We joke about this now, but we had to pull over to rehydrate from the tears that were flowing. We finished the book that night, and I knew that Ron needed an angel.

That next morning, bright and early, I was eager to create and went to my studio and painted an angel that would be a reflection of Ron's wife, Debbie—a "good and faithful servant" (Matthew 25:23). The painting cured and dried over the next several weeks, then I framed it and shipped it to Ron. A few days later the phone rang and the name on the caller ID was Ron Hall.

That was the beginning of a deep friendship and a love for serving the homeless.

Fast-forward many years later to when Ron and I were asked to be spokespersons at a homeless press conference in New York City. It was to be held the week before Thanksgiving at a homeless shelter. My business partner, Wendy, and I would be joining Ron and his new wife, Beth, in New York City for a quick two-day trip. I had even convinced Clark to come for part of the time—escaping the duties of his business—and to join us the next morning.

Wendy and I had been hopping all over the country, speaking and product developing, so a quick trip to New York City was easy for us the week before Thanksgiving. Ron had given us the name of the hotel where he was staying, so we booked two rooms for our stay.

At the risk of sounding like a diva here, I'll admit: I have certain standards when it comes to hotel rooms. You know, things like soap in the bathrooms, central heat and air, towels, no mold or mildew—you get the picture. I trusted Ron and his suggestion of the hotel that cost one-hundred dollars per night in the heart of the city. We were up for an adventure.

Wendy and I arrived and immediately started to question the state of the room

we would be sharing before Clark arrived the next day. No soap in the bathroom, two very thin towels, a trash can that was propped in the window to circulate some air, a flat, yellow-stained pillow that I really did not want to lay my head on—we laughed so hard at our previous expectations. I thought to myself, *We don't have to do this; we can go across the street to the fancy hotel and lay our heads down.* But instead we mustered up the confidence and agreed: we can do this.

We met Ron and Beth for a lovely dinner and a Rockettes show to put us in the holiday spirit. While walking back to our hotel, we stopped at a store to pick up the necessary and missing soap for our room. Walking out of that little store in the cold, dark night, our stomachs and hearts full, we saw a young woman in her mid-twenties sitting outside the doors. Bundled up in dirty blankets, she had the face of an angel.

Ron spoke to her and learned her name was Ashley. I pulled out some money from my wallet to put in her cup but then said, "Wait! We have another room!" We asked her if she wanted to come back with us and stay the night in a warm bed. Then we shared with her what we were doing in New York City and invited her to come to the mission with us the next day. She gathered her things, mainly a backpack stuffed with essentials, and followed us back to the hotel.

Wendy and I had not seen the other room when we had checked in earlier; we had just grabbed the keys and chosen the first room for our stay that night. When we got to our second room and opened the door, we were stunned. It was a beautiful suite, complete with a large bed and fluffy pillows, a bathtub, soap, and towels. Ashley looked at us and through her tears said, "Oh, how I would love to take a bath."

We sat and listened to her story. Every person experiencing homelessness has a story of how they came to be living on the streets. And each homeless person

God saw an

opportunity,

and He

provided.

is someone's child; most importantly, they are a child of God.

We took Ashley with us to the homeless shelter the next day. She was fed a delicious Thanksgiving meal, she made some contacts at the shelter, and then she went back to the hotel to gather her things.

I'm not sure what ever happened to Ashley, but I do know that God put us in that particular hotel that particular night for a particular reason. I know now why we didn't have soap in our room and why we had to make one extra stop before saying good night. God saw an opportunity, and He provided for a young homeless woman on a cold winter's night.

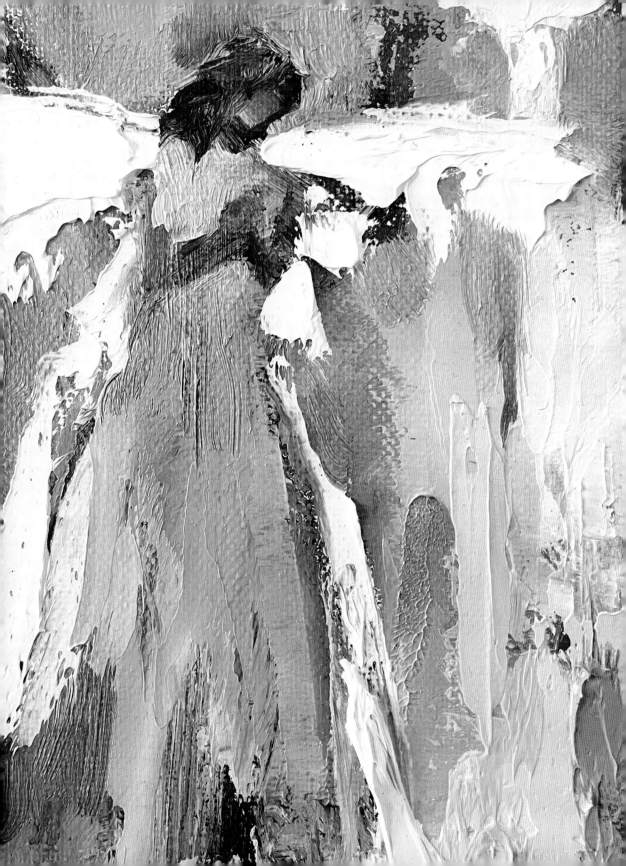

6

Stranger on the Road

"For the Son of Man is going to come in his Father's glory with his angels, and then he will reward each person according to what they have done."

MATTHEW 16:27

By Jimmy Wayne, country music singer and songwriter, and New York Times best-selling author

On a cold night back in 1992, around 11:30 P.M., I was driving home from the textile factory where I worked in Gaston County, North Carolina. The streetlights weren't very bright, but I could see someone in the distance alongside the road. As I got closer I noticed it was an African American man, and he was wearing only a white T-shirt, jeans, and shoes.

That's odd. It has to be thirty degrees out there, and he's not wearing a coat, I thought. Not to mention, he was walking in a part of North Carolina that still displayed Confederate flags and had some heartbreaking history, including the shooting of Ella May Wiggins in 1929. I drove slowly around him, and as I passed the man, I looked at him. He didn't raise his head.

Approximately a half mile ahead, I pulled into my driveway, ran into the house,

yanked a coat out of the bedroom closet, ran back outside, and waited inside the fence. A few minutes later I saw the man coming up the road.

As he got closer I yelled, "Hey, man, I brought you something!"

Initially he didn't see me. It was dark, and I was standing inside a fenced yard.

He didn't respond.

"Hey, sir, I brought you a coat. I noticed you weren't wearing one," I said.

The man stopped, turned, and stared at me without saying anything.

"It's cold out here," I continued to say. "You can have this coat." I handed it to him over the fence.

The man cautiously walked toward me and took the coat. He put it on and it fit him perfectly.

> A NOTE FROM ANNE: I received an email from a friend's husband with a link that said, "You have to watch this." I clicked the link and watched Jimmy Wayne's TED Talk. His story was so powerful I knew we had to meet. The connection was made, and I rallied my husband and my mom to join me for his concert in Charlotte, North Carolina. I invited Jimmy back to our home after the concert to hear more. Jimmy accepted our offer—and with guitar in hand, a fire on the porch, and me in the kitchen cooking filets and homemade chocolate chip cookies, it was another divine connection here on earth.

"Thank you," he said with a quivering voice and walked on.

Several months later I had planned to give my girlfriend an engagement ring that I'd been making payments on for the past six months. She was eighteen, and I was twenty. She was my very first girlfriend, and I loved her more than anything in the world. Although everyone around me had expressed their concerns about our relationship and even recommended we wait a little longer before tying the knot, we'd already been dating for two years, and I felt 100 percent sure I wanted to marry this woman—now.

One night I scheduled a romantic dinner date and had it all planned out. I was going to get down on one knee and propose to her in front of everyone at Western Sizzlin' steakhouse. I got a haircut, cleaned my truck, and ironed my shirt. When it was time to leave the house and go pick her up, I went to the closet where the ring was. I'd hidden it a month earlier—in a coat pocket. As soon as I opened the closet door, I realized the ring was in the breast pocket of the coat I'd given the man that night.

Needless to say, I didn't propose that night. Then several weeks later while I was at work, I discovered my girlfriend—who worked at the same factory—with another guy in the break room. They were holding each other tightly and kissing.

After we broke up I poured myself into my dream of becoming a professional country music songwriter and singer. Six years later I signed my first song publishing deal, followed by a major record deal with DreamWorks Records in Nashville, Tennessee.

The man walking alongside the road that night may or may not have been an angel, but I do believe without a doubt he was sent by one.

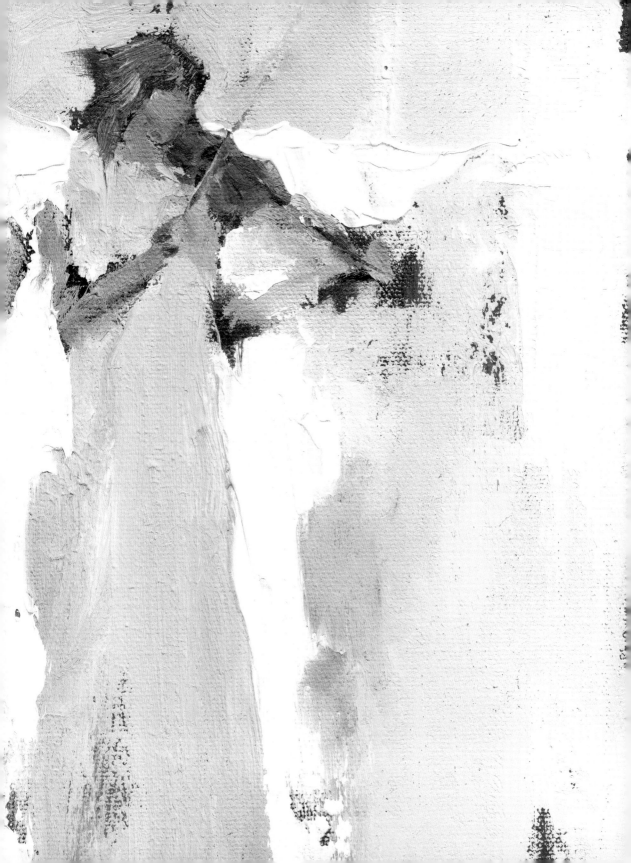

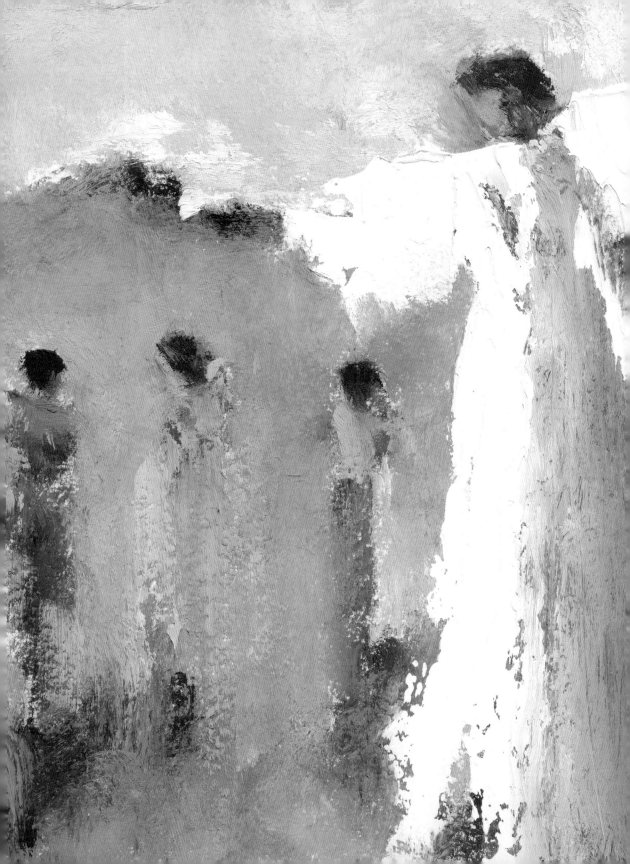

Falling Out of a Window

*If you stumble, they'll catch you; their
job is to keep you from falling.*

PSALM 91:12 MSG

By Anne Neilson

Waycross, Georgia. Do you know where that is?

My mom is from Waycross, and my cousins and I would spend summers at my grandparents' house—a two-and-a-half story brick home, with screen porches, brick patios, a long, green front yard, and of course a trampoline. To this day, I could draw a blueprint of the entire house. The things you remember as a child sometimes seem so large until you go back, and then they seem so small.

My grandparents had a little room off their bedroom. It was sort of an attic space with two twin beds and two dormer windows.

One day, when I was around two-and-a-half years old, I was with my younger cousin Charlotte. We had just been put down for naps but decided we were not going to obey and instead continued to play. The trim of the house had just been painted, and the screens had been just lightly set back in place and didn't offer any kind of security or stability.

This next part is a bit fuzzy, but as I remember that sunny day, Charlotte and I were playing a little game and I got the "hot seat" of sitting in the windowsill. The next thing I knew, I was falling, falling, falling onto a brick patio those two-and-a-half flights down. I landed just two inches from a brick column on that back porch. Charlotte, only two years old at the time, ran down the stairs crying and yelling in a mumbled voice, "Anne's fallen out of the window!"

It's funny now, writing this story and remembering parts of that day, but I came away from that fall with only a concussion and a swollen head as big as a watermelon. The doctors were amazed—not only did I live, but there were also no broken bones or additional damage to my tiny little body.

I like to think that an angel softly carried me down that day to lighten the blow and to position the landing. Two inches away from a brick column, with edges so sharp they could split you in half. There's no telling what the impact would have done to a toddler—one who was supposed to be napping! The rest of my recovery—taking care of a concussion—is a little unclear, but I do know one thing: I believe there were angels surrounding my grandparents' home that day. And I feel as though one somehow caught me as I stumbled.

Has an angel ever softened your landing?

Has an
angel ever
softened
your
landing?

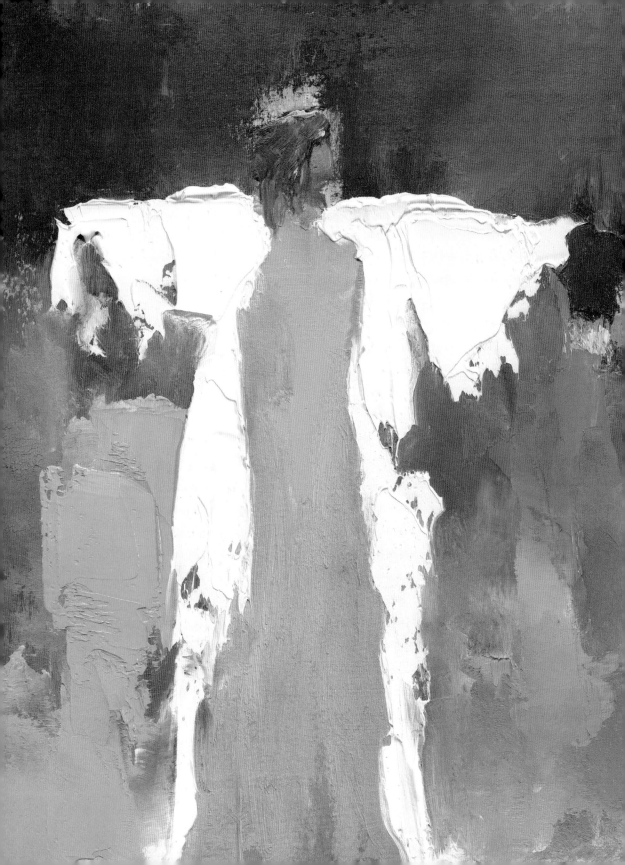

8

A Walk in the Wilderness

*"I will strengthen you and help you; I will uphold
you with my righteous right hand."*

ISAIAH 41:10

By Cheryl Scruggs, host of Thriving Beyond
Belief *podcast, author, and speaker*

I sat there, stunned and speechless. As I studied the Bible and journaled,
God laid on my heart the need to reconcile my marriage.

After I had had an affair.

After I had divorced my precious husband.

After I had allowed my family to fall apart.

I had so many people around me who said, "Cheryl, don't do it; you can't do it.
I doubt God will ever do that."

I had done things I wasn't proud of. I couldn't imagine picking up the pieces
and putting something back together that was so broken. I was scared, cautious. Yet
God was up to something *big*.

At the time, I learned that the Bible says God can do anything (Mark 10:27).
And yes, even what seemed impossible (Matthew 19:26). God made it very clear to

31

me that if I focused on Him, got out of His way, and made my life about bringing *glory* to Him, there was a good chance that my marriage had a *small* chance of being restored. I had no guarantee. I felt blind making my way down an unknown path.

Yet God gave me eyes to see, ears to hear, and angels. Luke 15:10 tells us, "In the same way, I tell you, there is rejoicing in the presence of the angels of God over one sinner who repents."

I had to ask myself, *Will I trust God?* I was willing to try God's way, though the odds felt stacked against me. As I fiercely studied my Bible, I began to realize one of God's patterns that I had heard from author and evangelist Christine Caine: "Impossible is where God starts. Miracles are what God does."[1]

I didn't know how to walk this faith walk He was calling me to. I had just become a Christian two months earlier and didn't know how to recognize God's voice through the Holy Spirit. First, I had to believe and accept that everything is in God's timing, not mine. I had to understand that He created me for Himself and for His glory, not for me and for my glory!

Waiting seven years on God to restore my marriage felt brutal. *Seven years!* God plopped me down on my own wilderness journey, just like Israel. In Exodus 13:17 Pharaoh finally let the people go, but God did not lead them on the shortest route through Palestine to the promised land. He knew they might change their minds and return to Egypt if life got too hard, so He took them the long way around through the wilderness.

God knows there is a shorter way to get us where He wants us to be, but so often He takes us the long way around and into the wilderness first. I grumbled and complained, without having any idea what God was protecting me from or teaching me by taking me the long way around.

My perspective of life before all this had been very shallow, all about me, and all

about *my* comfort—and all of that needed to change. My heart needed a transplant, one that actually *followed* Jesus and not just believed in Him.

Before I understood what it meant to have a spiritual heart transplant, I felt exhausted. But then I learned that God just wanted me to follow Him. "Trust in the LORD with all your heart and lean not on your own understanding; in all your ways submit to him, and he will make your paths straight" (Proverbs 3:5–6). He had to take me through a path of persevering and enduring with Him *before* He could even begin to show me how He was going to put my marriage back together.

I often became discouraged, but God sent angels—lots of them, too many to count—reminding me over and over how much God loves me, even after all I had done. He created me for *His* purposes, not mine.

Once I realized this it freed me up to live life with my arms and heart wide open, ready to follow His path for my life, instead of the path I had dreamed up. I surrendered to being interested in what God was interested in. And in order to do that, I had to be willing to be interrupted by Him.

God stopped me in my tracks. I had been going down a treacherous path and by His grace and mercy, He pulled me off of that path. He stopped me to listen to Him: "So do not fear, for I am with you; do not be dismayed, for I am your God. I will strengthen you and help you; I will uphold you with my righteous right hand" (Isaiah 41:10).

A NOTE FROM ANNE: I met Cheryl Scruggs through her daughter Lauren, who told me, "You would love my mom." The connection was made and another coffee date was put on the calendar. Cheryl and I sat for hours sharing stories. She has a powerful story of how God works in our messy lives. He is our hope and our Redeemer no matter what!

After I was interrupted by God, I became a conqueror—a woman who could follow Jesus and pursue the reconciliation of her marriage even though she had no idea how that could possibly happen. Still, God wanted to encourage me when I felt like giving up. After five years of pursuing reconciliation, it was getting harder and I was losing patience with my ex-husband, Jeff, who did not want to get back together.

I had to learn how to become a victor, not a victim. Sometimes I fell into a victim mentality, especially when life threw curveballs. I learned that it's what we *do* with the curveballs—the trials and the sufferings—that matter. So with God's help, I picked myself back up. I learned how to be victorious no matter the circumstances, because God is right there walking beside us even when we cannot walk ourselves.

When I realized I was a victor in Jesus—a conqueror—I could then trust and depend on Him, walk in victory, and do what He was asking me to do. I had confidence that God would show up. And then He did!

One of the first angels to intervene was during a car accident that Jeff was in. Jeff was hit by a car, and he called *me* of all people. I drove as fast as I could to the accident site. Jeff was stunned and shaking. He didn't have a scratch on him. I got in the passenger seat and he looked at me straight in the eye and said, "I think God is trying to get my attention." That day we decided to get remarried.

The next "angel" showed up one night when our daughter's friend was spending the night. This fifth-grade girl named Erika got brave and said to Jeff at dinner, "Mr. Scruggs, you need to get back together with Mrs. Scruggs! You love each other more than most married couples I know!" Out of the mouths of babes comes wisdom. God used Erika to speak the truth to Jeff, and it hit him over the head in a big way.

I realized God worked even when I couldn't see my way. I could count on Him to do the supernatural, the impossible, and to direct my path. And as I surrendered my life, one little thing at a time, I experienced a God who *can do all things.*

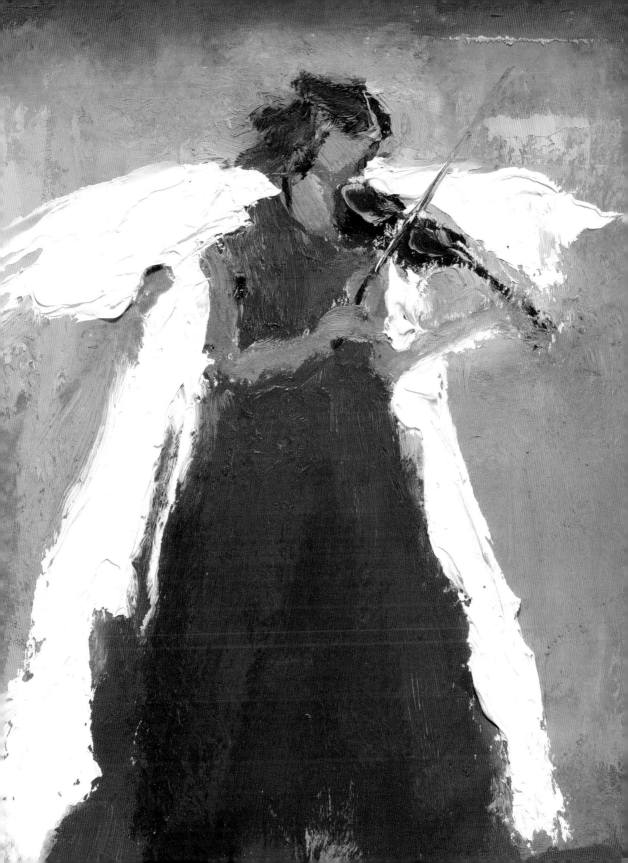

9

The Touch of an Angel

*For he will command his angels concerning
you to guard you in all your ways.*

Psalm 91:11

By Anne Neilson

Years ago, when my husband was courting me, he asked how many children I wanted. "Four," I said, emphatically. He said, "Four is a good number," and shortly after we got married, we started working on adding four to our family. We didn't have specific gender desires; we just wanted healthy babies. I did not find out the gender of the first three pregnancies and was elated each time. The girls came almost a year and a half after one another. I was the mom who had matching outfits on all three and huge, colorful bows.

We knew when it was time to add our final fourth. I got pregnant (quickly, like I always did), but early on I had complications and the pregnancy ended in a miscarriage. Devastated, we prayed and worked through our loss. We ended up getting pregnant again, only to have another heartbreaking loss. I started questioning. *Did God really want me to have four children? Maybe I'm supposed to settle with three. My girls are healthy, happy, and so beautiful. I should be content.*

But something was nagging at my soul that I was missing that fourth child, one of my heart's desires. I had so many of my prayer warriors praying over us as we navigated through those times of questioning. And then on Valentine's Day, I found out I was once again expecting a baby. And although I was extremely happy and excited, I was also filled with fear—that this pregnancy would end in disappointment again. Every day I had to surrender that fear to a God who carries it all for us. I was thirty-eight by this time and had a wonderful doctor who walked me through the journey of being an "old" expecting mother. With the exception of my husband missing one or two appointments, he went to every one throughout all of my pregnancies. And each time the doctors asked if we wanted to know the gender, we said, "No, thank you!"

Until the fourth.

Around the six-month mark, I couldn't handle the suspense. I called the doctor and asked if they would reveal the gender to me—and only to me. I learned we were having a boy, and then I had to keep that a secret for what seemed like a decade to me!

Then around eight months, I was at my weekly prayer group. This powerful group of seven women had been praying for several months on Friday mornings. We would set aside all the demands of the day and spend several hours every Friday worshiping and praying. We prayed for one another, our families, our careers, our churches, our communities.

I remember the day like it was yesterday. We were all popcorned around the room, standing in place, with our arms stretched to the heavens, worshiping to the praise music and praying in the Spirit. I stood there, with my arms stretched out, eyes shut, in a room full of the sweet murmur of prayers and praises. All of a sudden I felt hands lay on my quite-large belly, and I opened my eyes to see which of my

dear friends had come over to pray for this precious child in my belly—a child that the Lord had created fearfully and wonderfully. As I opened my eyes there was no one next to me. All of the other women were off in their own spaces—some on their knees, some standing, others crouched praying—but no one, not one hand, was near me. And yet I felt a presence, the supernatural presence of hands resting and laying on me as if praying for this child.

I've told this story to my son for his twenty-one years on this earth and will continue to tell him for the rest of his life. No matter what, God's hands are on you always and forever. I know God's hands are on *all* my children, but after the disappointment of losing two babies, I believe an angel stood beside me that day to reinforce the plans that God set out for me, guarding this baby boy who was about to be born several weeks later.

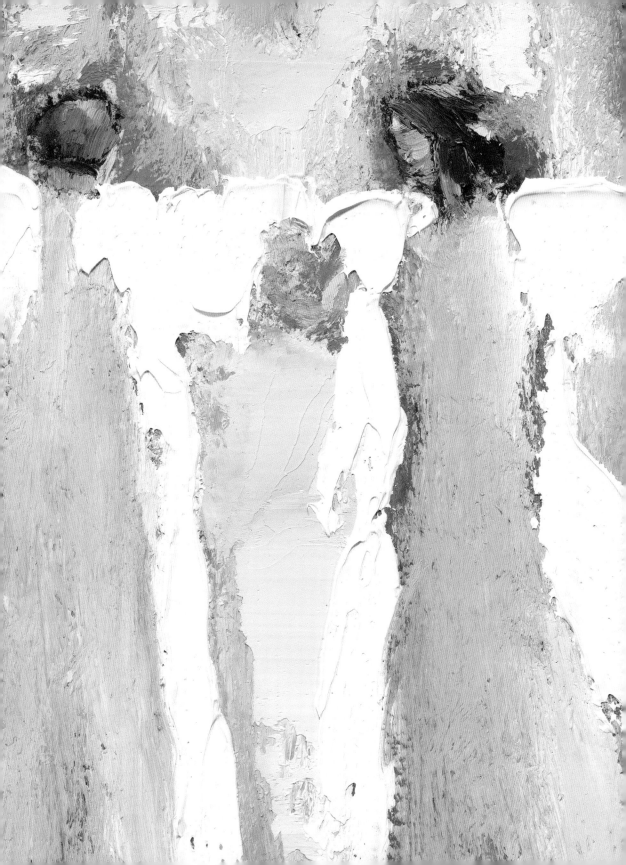

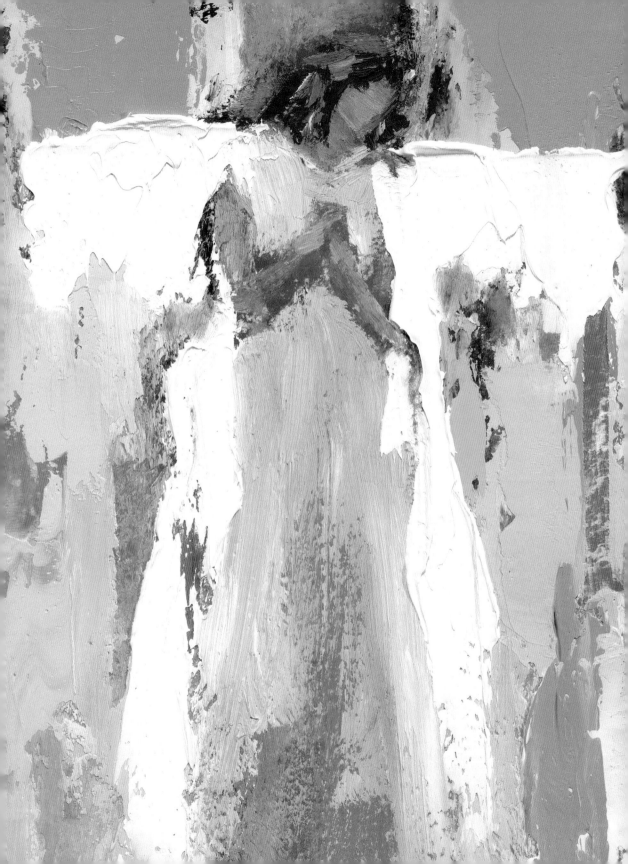

10

Doggone Feathers

He will cover you with his feathers, and under his wings you will find refuge; his faithfulness will be your shield and rampart.

PSALM 91:4

By Susan Brown, owner and founder of Grace 251

Feathers have always been a God wink for me. God started dropping me feathers about six years ago when my father was dying of cancer. I remember crying while I was prayer walking one day when my first feather fell from the sky. It was white, and it made me think of an angel's wings. In that moment it reminded me of God's nearness even in the darkest of times. A verse I've clung to that confirms these divine encounters is Psalm 91:4: "He will cover you with his feathers, and under his wings you will find refuge."

Since then feathers have been significant to me in many different ways. From seasons of hardship to seasons of celebration, feathers have meant everything from the peace of God to the presence of God to the playfulness of God.

One of my favorite such encounters was when my husband, my mother, and I drove to Charlottesville, Virginia, to pick up our new puppy. We were first-year empty nesters, and my husband just had to have a Wirehaired Vizsla that was

conveniently located nine hours away. He managed to rope my mother and me into this road trip by promising us a visit to Monticello, Thomas Jefferson's former plantation. While I was still unsure about this new canine addition to our family, I remembered a saying I had once read: "God spelled backwards is dog." I thought, *Well, anything that can show the unconditional love my Father in heaven gives is worth being open-minded to.*

While touring Monticello I became intrigued by a polygraph machine. The polygraph was built in the early 1800s and enabled Jefferson to duplicate his handwritten letters. I was even more amazed that it did this while using two synchronized quill pens. This was of vital importance to him because it allowed him to keep copies of all the letters he sent and know when he sent them. As an avid journaler, I fixated on this interesting invention for the duration of the tour. It seemed that Mr. Jefferson and I both cherished having noteworthy memories live on a page forever.

After the tour we visited the gift shop. Immediately, a huge display of quill pens caught my eye. The thought of journaling my God stories with a feather pen made my soul smile. As I browsed the selection, every color was available except white. In addition, all of them had *Thomas Jefferson* engraved on the side. Disappointed, I walked outside and muttered jokingly to God, "I don't want a red one, I don't want a green one, and I don't want a Thomas Jefferson one. I want a white one from You." I chuckled to myself at the thought of this goofy request of the Lord.

On the way home after picking up our sweet pup, Gracie, whom my husband named after my Christian store in an attempt to earn brownie points with me, we stopped at a gas station. I walked Gracie over to a patch of grass for a quick potty break. When I looked down I screamed. Right there next to our new "God-spelled-backwards" dog was the whitest, largest, prettiest feather I'd ever seen. This feather looked more like a quill pen to me than any I had seen in the shop that day. I knew

instantly that this was God fulfilling a silly request made by His daughter. He can use any situation, any time, and anything to communicate with His children—even a dog. I believe there are no coincidences in this life. I also believe that God can be found in the simplest details when we are searching for Him and are in constant dialogue with Him.

One of my favorite quotes by pastor and author Mark Batterson

A NOTE FROM ANNE: Today I sell my angel paintings in more than eight hundred stores across the country. Susan Brown owns one of those wonderful stores. When I arrived at her store in Dalton, Georgia, for a book signing, I discovered a joy that permeated the place. I didn't want to leave! She shared story after story about how God had showed up in her life. I left refreshed and on fire for my own calling. This is just one of her many angel stories.

is, "When you pray to God regularly, irregular things happen on a regular basis."[2] I love this because it rings so true in my own life. The more I seek Him with my whole heart, the more crazy experiences like this one happen on a regular basis. This is just one of the many fun stories in which God has shown me His presence and that He listens to me. If God cares about little things like a quill pen, how much more will He be with us in the big things? He is a good, good Father who loves to give His children the desires of their hearts when they take delight in Him.

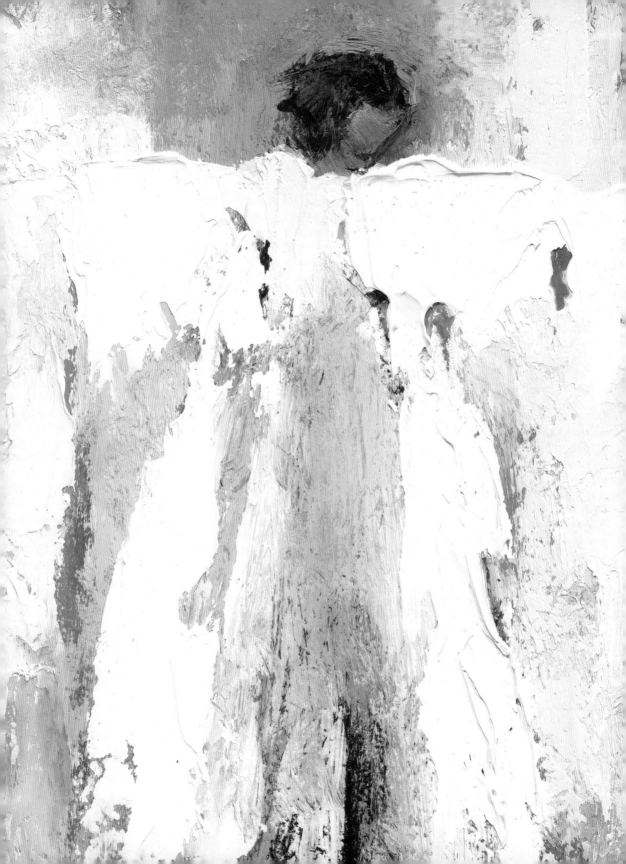

Look Up

"I say unto you, Lift up your eyes, and look on the fields; for they are white already to harvest."

JOHN 4:35 KJV

By Anne Neilson

*Y*ou are so busy!"

This is the number one thing I hear from people. And I've had to make it clear in some of the talks I've given, and even in my devotional book, that I never want to glorify *busy*. Too many of us wear it like a badge of honor. Instead, I like to think I'm busy doing all the things God has called me to. Even so, I'm still prone to racing around and checking things off my list, and I still sometimes get in a last-minute frenzy and scurry around town to get things done.

This was one of those days.

We were hosting a dinner party, and I had some errands to run to get everything we needed for entertaining later that day. Last on my list was finding a new set of place mats, so I whirled into the parking lot at Crate and Barrel. With phone in hand and keys in pocket, I rushed in and grabbed what I needed, then set everything down at the back counter.

As the store clerk scanned my items, I was knee-deep in checking emails on my phone, not paying attention to the clerk. I heard her comment on my wedding band.

"Beautiful ring," she said.

Without looking up, I mumbled, "Thank you."

She said something else, and I felt the nudging of the Holy Spirit telling me to put down my phone and look up.

I obeyed, and when I looked at this woman, she was the most striking person, with beautiful eyes and a contagious smile. We engaged in conversation, and she asked me what I thought the secret to a great marriage was. I had been married for about twenty-four years at the time, and my comment back to her was plain and simple: "Jesus." I shared how He knits us together through all the messy parts of marriage and life, through His love and His promises, and that He can keep a marriage together.

Tears streamed down her face. She shared that she had just gone through a divorce and moved to Charlotte, North Carolina, to start a new life. Thankfully the store wasn't busy, so we talked a little longer, all the while I prayed to offer a few words of encouragement. As I left the store with my purchases, I felt like the Lord had just placed an angel in my life—someone with whom to pause and truly connect. Or maybe I was the angel in *her* life that day, bringing encouragement to a struggling person. Either way, I left that store feeling God's divine presence and also feeling a little lighter. With my phone tucked away in my back pocket and a grin stretching from ear to ear, I was so touched that I had listened to the voice of the Holy Spirit—and not only had I listened, but I had also obeyed—and He blessed me with this beautiful connection and a reminder that He always has our best interests at heart.

As you go about your own days, please don't forget to stop and look up.

He *knits*
us together
through all
the messy
parts of
marriage
and life.

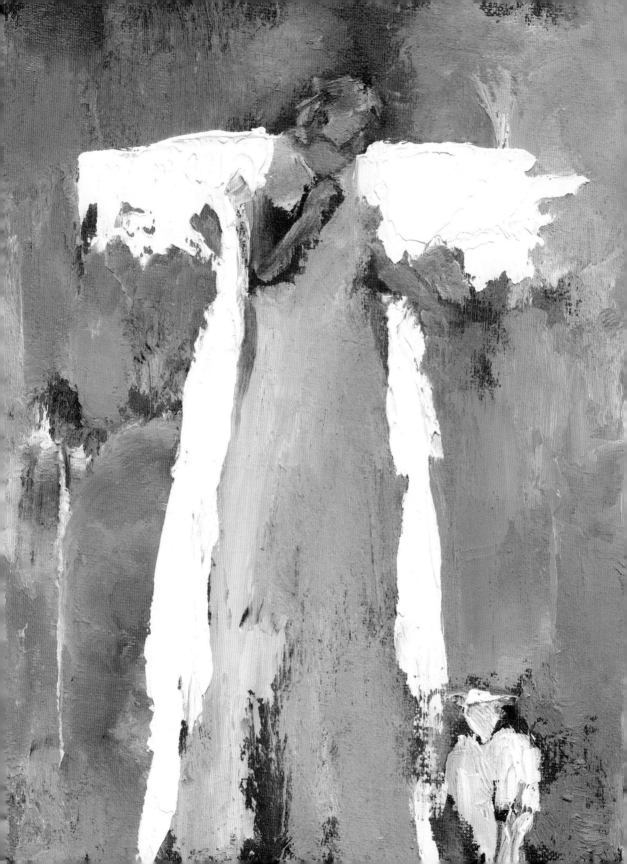

12

No Greater Gift

*The peace of God, which surpasses all understanding, will
guard your hearts and your minds in Christ Jesus.*

Philippians 4:7 esv

By Jamie Heard, founder of Faithfully Restored

On December 11, 2015, I received a call that no parent wants to receive. Our two-year-old son, William, had choked at lunch and he wasn't breathing. I felt like the wind had been knocked out of me, and I knew the situation would not end well. I had woken up early that morning and spent extra time praying for God's will to be done. I felt the weight of that prayer as I grabbed my purse and left my office.

On my way to William there was a peace I felt deep within me. I kept repeating, *We rest in You* and *Let Your will be done*, as I frantically drove to the hospital.

When I first arrived at Williamson Medical Center in Franklin, Tennessee, and saw William, he had no pulse. He had an emptiness in his eyes that confirmed to me that my son was gone. My husband, Daniel, and I held each other and cried as the doctors told us they would give him one more round of medicine, their eleventh attempt, to try and get his heart working. Within moments his heart began to beat again.

William was then taken to Children's Hospital at Vanderbilt in Nashville. He never showed any sign of brain activity, and as hard as it was, we knew early on that our little boy was in the arms of Jesus. It was painful to see his perfect-looking body lying there in bed and to know he wasn't ever going to wake up. I remember sitting in the waiting room that first night, surrounded by what felt like a hundred people, and wanting to scream. *How was it all going to end? Do you pull the plug on a two-year-old?* God had given me a complete peace about losing William, but I was so confused as to why his heart started beating again.

The following morning, after sitting in a meeting with the "what's next" guy at the hospital, God gave us one reason as to why William's heart started beating again. Tony, from Tennessee Donor Services, presented us with the opportunity for William to become an organ donor, and we immediately felt led to do so. The thought of our son being able to help someone else have a new chance at life gave us a feeling of hope that something good could come out of this tragic situation. A glimpse of light in a very dark time. Our family began praying that God would allow William's organs to benefit someone in need of help.

In agreeing to participate in organ donation, William would be kept on a ventilator for a couple days in order to match as many organs as possible. This was an answer to prayer and a gift. We spent the weekend holding William's hand and running our fingers through his perfect sandy-blond hair. Friends and family came from all parts of the world to say goodbye to our sweet boy. We wouldn't trade those two days for anything, and we are so grateful for that time with his precious little body.

On Sunday we got word that William's heart and kidneys had been matched and a surgery time was set for Monday morning. It meant so much to me that his sweet little heart was going to keep beating.

Daniel and I were able to spend several hours with William before surgery, snuggling and loving on him. We watched as the medical team performed some last tests on William's heart to make sure it was healthy. It was perfect. We didn't want to let go of our boy that morning, but we prayed that he would be able to give life to another child. Little did we know that hundreds of strangers were praying

A NOTE FROM ANNE: I first met Jamie Heard through social media. She often purchased our Scripture cards to place in her care packages for women going through tough times. I dug a little deeper into her ministry, Faithfully Restored, and knew we had to meet in person. She has a powerful story to share. Even in the midst of pain and brokenness, God can and will restore our hearts!

for our family as a little girl in Chicago was desperately waiting for a new heart.

The next day, through a friend of a friend, we learned about sweet Ava Martin, a one-year-old who had been in the hospital for 111 days awaiting a heart transplant. We wondered if she would be the recipient that we had prayed for. We found a news story online from the night before that detailed her heart transplant journey. Her parents, Brian and Amie Martin, were interviewed and the joy on their faces was priceless. We began to piece together a timeline. The same day that William's heart was removed from him, Ava received a new healthy heart. The couple was interviewed and explained how they were praying for a family that, even in their darkest hour, would choose life and would honor that life every day. I felt a spark of joy after watching that video that I didn't think would be possible to feel for a long time. It was another answered prayer.

My girlfriends and I began to search social media for more information about Ava. We researched blood types that were compatible in a pediatric heart transplant. One by one, the pieces of the puzzle came together. I was hesitant to believe that we

could have identified William's heart recipient so quickly, but something told me that Ava was our match. After finding Ava's mom on Facebook, I decided to send her a personal message. I could tell from the video what a kind and compassionate believer she was, and I just had to reach out to her.

Amie got right back to me, and we spent the next few hours sharing our stories with each other. We sent pictures and videos of our kids. Before long, we both knew that little William's heart was now beating strong in sweet Ava's body. That same heart that Daniel and I prayed over before William went to surgery was the same heart that Amie and Brian said was "the most beautiful sound in the world . . . your gift of life, your son's gift of life." It was an answered prayer for both of us.

The Martin family has become some of our best friends. We spend holidays together, vacation as couples and families, and never go too long without seeing each other. William's older sister, Madeline, and younger sister, Annie, consider Ava and her older sister, Ella, their family. The bond between us is unique, and the story is one only God could write.

The story of William and Ava provided our family with hope during what felt like a hopeless time. Our hope was not and is not in Ava, but in a God who meets our every need. Even in the most difficult circumstances, we serve a God who is faithful and grants us peace, a peace that can *only* be found in Him. When we trust in Him, our hope is restored. I know there will be more people in heaven because of William's story. As a mom there is no greater gift.

"Do not be anxious about anything, but in everything by prayer and supplication with thanksgiving let your requests be made known to God. And the peace of God, which surpasses all understanding, will guard your hearts and your minds in Christ Jesus" (Philippians 4:6–7 ESV).

13

Add to Cart

*Be kind and compassionate to one another, forgiving
each other, just as in Christ God forgave you.*

Ephesians 4:32

By Anne Neilson

The grocery store is not my favorite place, and I will put off going for days. However, there was a particular day when our household was getting low on the usual goods—not to mention the fact that some items were growing mold—and it was time I journeyed to the store.

I picked up the essentials, then shimmied my cart to the shortest checkout line available, antsy to leave and take off my face mask. (This was in 2021 during the COVID-19 pandemic.) As I stood at a recommended social distance and was the next in line to check out, I did a quick scan of my grocery cart, hoping I hadn't forgotten anything. I turned to glance at the aisles behind me to spark any memory of a potentially forgotten item, and just then a young mom and her four-year-old son sneaked behind me with three items in their basket: some meat, bread, and milk.

"Excuse me, ma'am," the mother said, interrupting my distance-browsing. "I'm trying to get back on my feet. I've just moved here and am staying at the battered women's shelter, and I'm just wondering if you could help me."

I smiled and looked over to her precious little boy and said, "Is this all you need? Seriously, you've got to need more."

"No, no. Just this will be fine."

"But what about some fruit?"

"Well, we could use some grapes."

I picked up the little boy and put him in his mom's cart and said, "Well, let's go shopping!"

We went up and down the aisles gathering fruits, veggies, snacks, and eggs, and we loaded up her cart. I just kept smiling and telling her she needed a little more. "What's your favorite fruit . . . snacks . . . meats?"

As we shopped, I got to know a little more about this mother who had relocated to the Charlotte, North Carolina, area after escaping an abusive relationship. She was put up at the women's shelter and had just started a job at the hospital. She was very grateful for all the people God had sent along her rocky path.

With her cart now full, we ended back at the checkout line. I put her basket before mine and started to unload. Then I hugged her and prayed for her, and said goodbye.

But the story doesn't end there.

It was now time for me to get my own groceries and check out. Christine was the store clerk behind the register that day, and she realized I didn't know the woman whose groceries I had just paid for. Christine was upset about what I had done, saying they always come in begging and that I shouldn't have paid for her groceries. She even called the manager over to reinforce her message.

"Where is she? What did she look like?" the manager asked.

I looked straight into the manager's eyes and told him, "You never disobey the Holy Spirit's prompting, especially when it comes to giving. If Jesus tells you to do something, you'd better be ready."

The *world*
needs more . . .
laughter,
more grace,
more *generosity.*

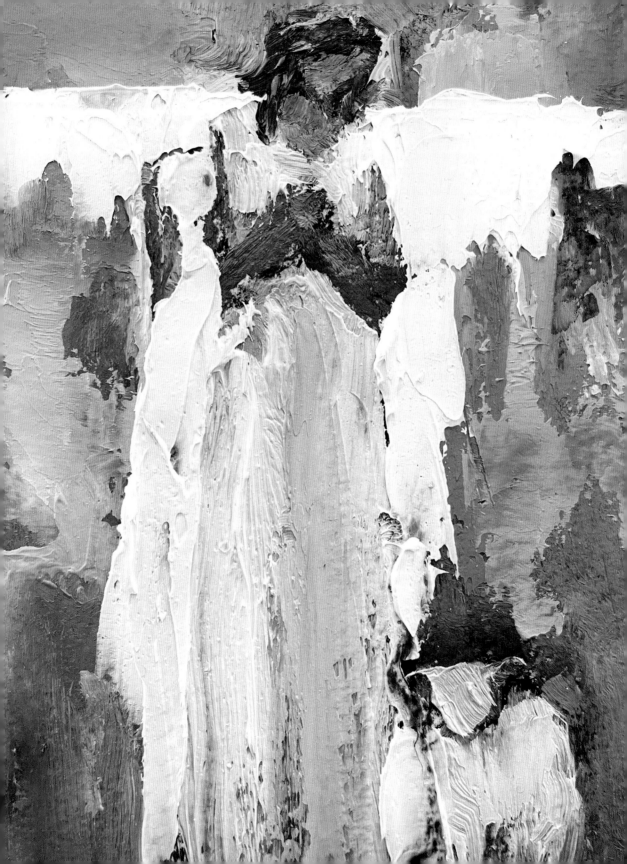

I explained what it meant to have a servant's heart and that I love to give. And if this woman was truly just a beggar, well, then that's up to God to deal with.

The manager mumbled, "Okay," and walked off.

As I turned back to Christine, it was time to pay for my groceries. She asked if I wanted to round up my bill to make a donation toward a charity.

"Now, what do you think?" And with my reply she let out an infectious giggle. I told her that is what the world needs more of: more laughter, more grace, more generosity, more reaching out to those less fortunate. God tells us "to whom much is given, from him much will be required" (Luke 12:48 NKJV).

As I wheeled my groceries past the bagger, he said, "Ma'am, that was an honorable thing you did. Thank you."

But wait. There's more!

For days I could not get Christine off my mind. I know that every day she experiences people who shoplift, or who beg, and even those who do much more bizarre acts in the store. I couldn't blame her for wanting to protect the store and the other unsuspecting customers from being taken advantage of. She was trying to do her part. But her smile and laughter afterward just kept coming back to me. So a few days later I sat down to write her a note and signed a few of my angels books to her. I pulled my car up to the front of the grocery store and asked an employee who was pushing in the grocery carts if Christine was working that day.

"Yes, ma'am. She is at her station, the number one lane." I went in, with gifts in hand, and looked into her eyes. "Remember me?" And then I handed her my books as a gift.

Whether a whole bunch of us were either entertaining angels or being entertained by them that day—including the young mom, her sweet son, Christine, the store manager, the bagger, and me—I can't help but think God and His host of angels were somehow involved. Perhaps with that small, random act of kindness, they were moving in people's lives in even more ways than I'll ever know.

14

His Eye Is on the Sparrow

*"Do not fear; you are more valuable than
a great number of sparrows."*

Luke 12:7 nasb

By Amy Carlisle, wife, mother, and artist

I come from a family of artists. My grandmother was an artist; she traveled from continent to continent, painting. My mother is an artist; she had a scholarship to college on her talent. My sister sings like an angel, and my brother is a blues singer.

I am all of these, and yet as a young woman, I never felt confident enough to pursue my gifts wholeheartedly. So I became a dental hygienist, met a Southern hunk, and moved to Memphis, Tennessee. I spat out four kids faster than lightning and loved being a stay-at-home mom, thriving in the normal joys of everyday life. One thing I always wondered, though, is why the Lord spared my life in a horrible car accident in high school. "Can't I do something great for Your kingdom since you left me here?" I would ask Him. Mothering my children is my number one calling, but for whatever reason I knew something else was coming.

One day when my four children were little, I needed extra money so I revived my dental hygienist skills. While cleaning a woman's teeth, she told me her kids had

just been diagnosed with, and wouldn't survive, a rare, genetic neurological disorder called Batten disease. I silently prayed over her that day. I went home and tucked my kids into bed that night and wept. I told my husband, "I think I need to try and help— maybe I should paint?" After all, God had given me this gift, which wasn't being used. Time went by. I was so busy changing diapers and wasn't brave enough to try.

A few years later, my husband called me with panic in his voice—our child had just had a seizure. I was scared to death and got a bone chill when asked if we had ever tested our child for Batten disease. We spent months trying to get a diagnosis. In that time at Le Bonheur Children's Hospital, the uplifting art decorating the walls grabbed my eyes and made me feel better in between moments of worry.

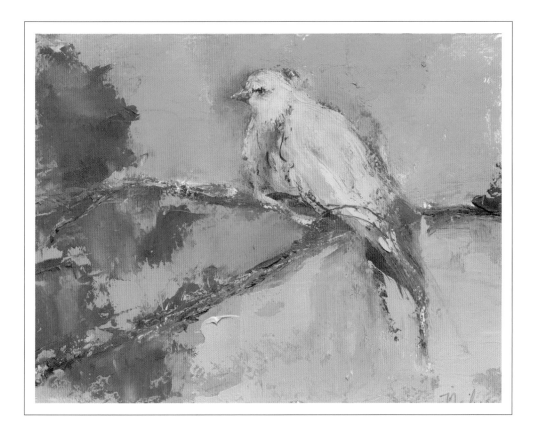

A NOTE FROM ANNE: When we were in the planning stages of *Entertaining Angels,* I wanted to hear others' stories. We all have them; we just need to dig deep to see God's hand moving. I asked my social media followers for their angel stories. Amy Carlisle, being a fellow artist, had one of the stories we chose. I haven't met Amy in person but know God has touched her heart as an artist. Enjoy this story knowing that His eye is always on the sparrow . . . and on you!

I was especially emotional one day at home while cleaning the toilets (we had a house full of boys!), and I cried out to God, "Father, what is all this for?!"

I heard in that moment, *Help families. Find that mother.* I knew whose voice it was, and I knew it was time for me to come out of my insecurities and give Him my gifts with all my heart. My music, my art; it all belonged to Him. I then heard, *Paint!*

That is how my art started. I studied my grandmother's art sketches, and I painted my way through tears of worry for my own child and grief for the mother I had met years before. In between brushstrokes I stared at a painting that my grandmother had made of birds, and the Lord whispered, *The birds of the air don't worry. I take care of them. Paint.*

I finally did what God told me to do: I found the mother whom I had prayed over many years ago. I took her the very first bird painting I ever made.

"I can't believe it's birds!" she said. "Do you know I had a sparrow tattooed on my wrist in honor of Milla's life? She loved birds so much, but it's also a reminder that God's eyes never leave me. So I am just floored that you have a painting of birds for us."

I was told Milla had lost her vision, but she could still hear the birds chirp.

Given how special birds were to this family, this moment was the first of many experiences God had planned where I saw Him use art as a way to bring healing and bring Himself glory.

God blew my mind, but that was just the beginning of how He would use art as a way to bring comfort. I now sell my art in galleries and interior design stores, and I send 10 percent of every piece I sell to a foundation in memory of that little girl and her sister, who is now with her in heaven. Kids are able to receive free grief therapy from this foundation, Milla's House, in Memphis. I also send paintings in the mail to mothers who have lost their children, along with a children's book written about heaven. I've seen God pay for shipping. I've seen God deliver a painting for a grieving mother I had been called to paint for but didn't know. In this instance, a friend of mine from Austin, Texas, randomly went to a Bible study, and the mother who was to receive the painting unexpectedly sat down right next to her. When they exchanged names, I know she was surprised when my friend said, "Umm . . . don't think I'm crazy, but I have a painting in my closet that is intended for you that was sent all the way from Tennessee. We just moved here."

These stories go on and on as God continues to allow me to paint for others. The spiritual lesson He imprints on my heart each time He calls me to paint is this: don't hide your gifts! You never know why God placed them in you. My goal is to keep high-fiving the Lord as He sells my art, leaving me the ability to keep giving to more grieving parents and to the foundations that help them. My child is seizure-free today, and we continue to be grateful for healing.

I mainly paint church scenes now, to represent healing in relationships and my love for the South. My mother painted them when I was growing up. She wanted to see diversity in the churches of the South. Her wish is coming true. I have never stopped painting bird scenes, however, always remembering Milla and her family. I send them into the world to spread the news that God's eyes are on the sparrow, and I know He watches over us.

15

You've Got Mail

Then I looked and heard the voice of many angels, numbering
thousands upon thousands, and ten thousand times ten thousand.
They encircled the throne and the living creatures and the elders.

Revelation 5:11

By Anne Neilson

Owning my own company and seeing what God has done with every brush-stroke on the canvas has been immeasurably more than I could ever ask or imagine, and it fuels me to do even more than I was already doing. Everything we do at Anne Neilson Home is done with excellence—from the way we handle each item with care when packaging and shipping, to how we handle our customer service. I challenge you to find a Bible verse about doing work for God's kingdom that talks about doing anything with less than excellence.

Our company has grown so much since 2012 when my first book was released, and we now have our own fulfillment space where I can manage every little detail and make sure that everyone is taken care of. Our customers come first, forever and always.

One day I decided to print out all of our orders and begin the process of selecting

and packing products, and getting them ready to ship to customers. I love this process because I love seeing where people are purchasing our products from and reading any messages they might have.

Well, I somehow missed a very important message on this one order. The customer had purchased my first book, *Angels in Our Midst* (a seventy-dollar value), to be shipped out overnight to her mother-in-law for a birthday gift. *Overnight!* I had completely overlooked the *overnight* part and neatly stacked this order with several others that were set aside because we were out of our specially sized book boxes.

Days went by and I was still waiting on the boxes to arrive. Nothing. And because I am a picky packer, I didn't want to have this particular book swimming in a box that was too big for its britches, so there the order sat. *Days*, I'm telling you.

Midweek I received a message from my business manager who shared an email from an angry customer—so much anger that she called me a *lazy ass*. She wrote about how she knew I was a faith-filled person and how being lazy surely did not reflect well on my faith.

Now I can certainly be called a lot of things, but *lazy* is not one of them. In a panic I had to get to the bottom of what happened. As we uncovered the details in her order, I realized it was I who had dropped that ball. Immediately I called my team to reach out to her and overnight her a new book. Our staff sent messages via email and even called in case any of the messages went to spam. I wanted her to know how sorry we were, and I wanted it done yesterday!

Time passed as we waited anxiously to see if our frustrated customer had received any of our messages. Crickets. Finally, around noon, I picked up the phone, dialed her number, and personally left her a message.

Still pacing around the studio, I searched for ways to make this right. And then a little later, the phone rang: it was her!

I am *grateful* for all the ways that God *connects* His people together, even in the midst of a mess.

"Oh, I am so glad you called me back!" I exclaimed. And then I burst out that I was not a lazy ass, but that it was all my fault. I took full responsibility for leaving her book on the table, waiting for the perfect box and completely missing the fact that she had spent sixty dollars to overnight a seventy-dollar book. I kept apologizing and told her I would make it right. In the midst of the conversation, *she* started apologizing to *me*.

She explained that she had never meant to send the email, but under the stress of her week—and in the absence of her husband who had been traveling all week—she had had enough. She took out all her frustrations on me in that email and . . . accidentally pressed the Send button. After laughing and crying we stopped and assessed the situation. We realized that if I had not been the one to drop the ball and pause her order, and if she had not sent that angry email, then our paths would not have crossed.

As it turned out, she needed an angel to listen, someone to hear and understand her frustrations of the week—on top of the already chaotic year our whole world had just had. I suggested, "God put me in your life right now, on this call, to pray for you and all that you are going through."

I prayed. We cried.

And then I made sure that the book was sent to her mother-in-law. Perhaps it was her mother-in-law who was the "angel in our midst" as the customer and I exchanged a few more encouraging emails after that. I am ever so grateful that I was the one who messed up that order, not realizing until later that God had bigger plans for us both. I am grateful for all the ways that God connects His people together, even in the midst of a mess.

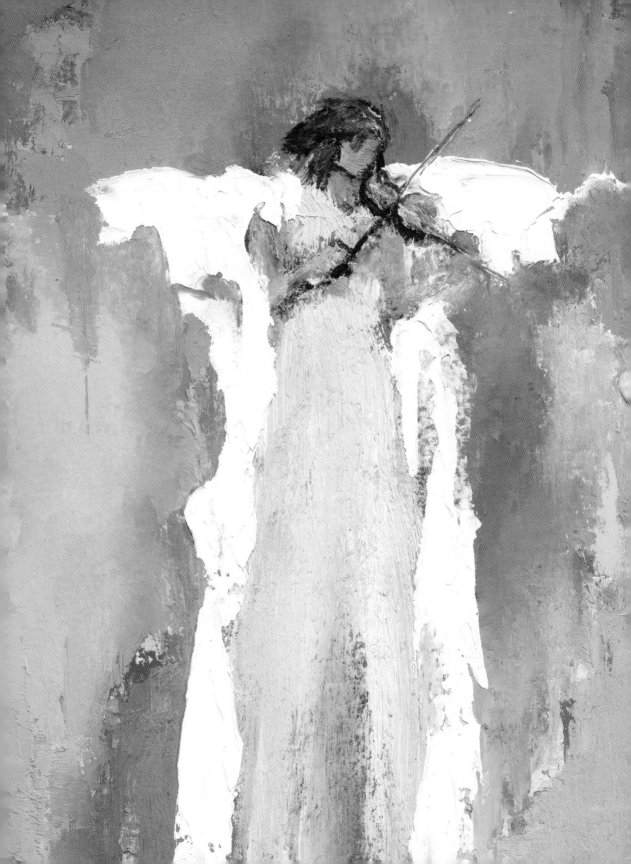

16

Earthly Angels

Are not all angels ministering spirits sent to
serve those who will inherit salvation?

Hebrews 1:14

By Jacob Paul Bright, owner of Fine Things

The night before Thanksgiving of 2019, I was spending the night at my best friend Johnny Burks's house. After I got off work, Johnny and I did an easy run and then went to Fleet Feet to pick up our race packets for the UAH Turkey Trot 5K, which was early the next morning. When we got back to his house, I saw his neighbor, Sean Kelly, leaving for his farmhouse. I wished him a happy Thanksgiving and asked him if he'd be back at work on Monday. His wife, Belle F. Kelly, was having dinner with friends, and their kids were gone.

Johnny's wife, Alana, had gone to bed early to get up the next day to cook for Thanksgiving. Later that night Johnny and I were in the living room watching an old, funny favorite movie of ours. We knew we had to go to bed soon and get up early for our annual 5K. A few minutes before 10:00 P.M., while we were finishing up our movie, Johnny got up to lock the front door and turn off the front lights. As he approached the front of the house, I heard a loud scream. I thought, *Oh no, he has fallen and broken his leg!*

A NOTE FROM ANNE: Jacob Paul Bright is another amazing store owner who sells our angels. I met him a few years ago when he hosted a book signing in his store nestled in Arab, Alabama. It was another Holy Spirit–filled moment as I walked into Jacob's store and signed more than a hundred books while meeting new friends and hearing stories. Jacob's story is powerful, and we had to share it with you. Thank you, Jacob, for believing in angels and being such a supporter of my work.

Barefoot and wearing only my lounge shorts and T-shirt, I jumped up off the couch and went running toward him. I looked out their side window into the dark night and saw a huge fire blazing next door. Belle and Sean's house was an inferno. I ran outside toward the fire, still barefoot, chasing Johnny. We knew nobody was home, except for two dogs and a cat.

Alana woke up with the commotion and joined us at the Kelly's house. Johnny and I broke into the side door—the top part was glass. Since I was barefoot I couldn't go into the smoke-filled house, now littered with broken glass everywhere. Johnny went right in to save the animals. He found both dogs and handed them to me one at a time. When Johnny handed me Willard, he was lifeless. I started crying, holding him so limp. Alana and I just started breathing into him, and he came back to life. When Johnny handed me Shug, she was so heavy that I couldn't pick her up. I felt so useless, I cried and screamed for help. Out of nowhere, this young, tall, strong man appeared behind me. He asked what I needed help with. I told him Shug was too heavy for me to lift. He bent down and just swooped her up to safety. The house completely burned down. Both dogs survived, but unfortunately the cat was found dead, upstairs underneath a bed.

Later that night when Belle arrived to her house on fire, I explained my story to her. I said that when I was crying for help, God sent me a strong angel from out of the blue.

For Christmas that year Belle gave me the beautiful coffee-table book *Angels in Our Midst* by author and artist Anne Neilson, along with a bottle of Whispering Angel rosé wine. She said the Burkses and I were *her* angels the night of her house fire. I had never heard of Anne Neilson, but I treasured my beautiful gifts from Belle. I'd always believed in God's angels.

Not long after, in 2020, a global pandemic hit and I had to close the doors to my retail store, Fine Things. Everything was in lockdown.

One day Kim, one of my reps, called to check on Fine Things. I placed a reorder with her, and when we finished, she told me about other great lines that she reps. She mentioned an angel artist and author and said she would email me her info. As soon as I opened up my email, I called Kim back immediately. I totally recognized "Anne Neilson Home" because of the book Belle had given me. I told Kim my story about the fire, and even started crying while telling it all, and we both agreed I had to have Anne's products at Fine Things.

And then not even a year later, in February 2021, Anne Neilson came to Fine Things to do an incredible book signing. My customers fell in love with her—and so did I. I shared with Anne and my customers my God/angel story and cried again while telling it.

God is so good, all the time. I'm so fortunate for all the earthly angels He has sent me—and continues to send me.

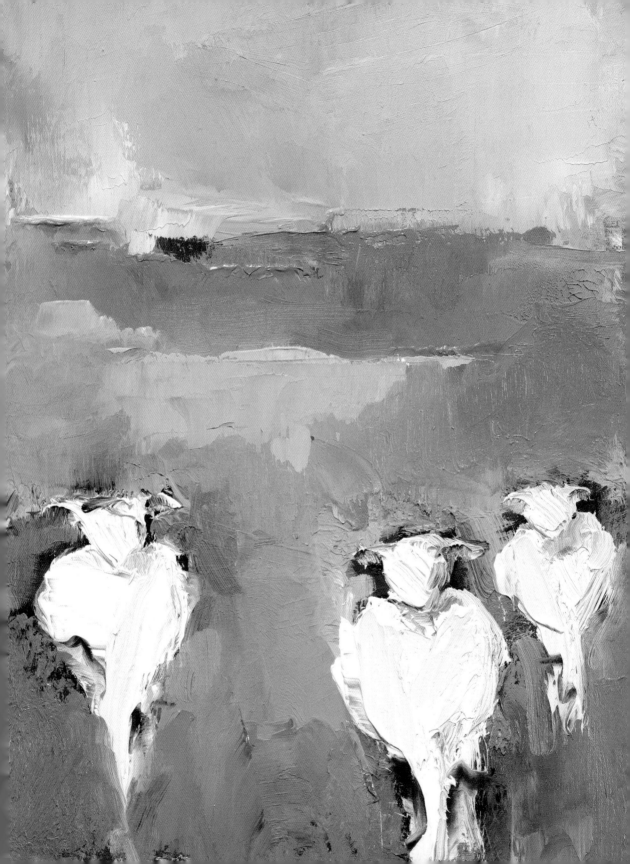

Do You See What I See?

*For in him all things were created: things in heaven and on earth,
visible and invisible, whether thrones or powers or rulers or
authorities; all things have been created through him and for him.*

COLOSSIANS 1:16

By Anne Neilson

I've shared this story before, but as I'm writing about entertaining angels, I can't help but include this one.

One summer my incredible stepfather of twenty-nine years, Bronson, was going in for heart-valve surgery. He was healthy and ready to get this procedure behind him so he could continue to enjoy the fantastic life that he and my mom had built together. My stepsiblings, my sister, and I traveled to Charleston, South Carolina, to be with my mom and Bronson for the surgery. Pre-op appointments were made and checked off the list, and the date for surgery was scheduled. The afternoon of the surgery, we all piled into the waiting room and shifted from sofa to chair and back to the sofa, fidgeting and gathering all around—praying, waiting, and praying some more.

It was a long wait.

Finally, after several hours the doctor came out and gave us the news that Bronson had lost a lot of blood and that it did not look good. He was in an induced coma. The following forty-eight hours were a blur, but we all somehow rallied. We stayed, we prayed . . . and we expected a miracle. And then we waited some more.

A few days in my stepsister and I went for a long walk. We arrived back at the hospital, and Bronson was out of the coma. We thought that there was light at the end of this painful journey of waiting. We walked into his room: my stepsister on one side of his bed and I on the other. He kept looking at me and furiously pointing to different parts of the room. His eyes fixated on me. Bronson wasn't making sense, and we tried to figure out what he wanted or what he needed.

"Do you want the TV on? Do you need the nurse?" we asked.

He shook his head and kept pointing. Perplexed, my stepsister and I just looked at each other and tried to figure out what Bronson so desperately wanted—or what he wanted us to know.

We finally just calmed him down and gracefully left the room. Then we called a family meeting. We had all been there for more than a week by that time. Bronson was coming out of the woods, and we felt we all should take a break and move to visiting shifts. I didn't want to leave, but I felt like I should head home to check in with my family and return later for my shift.

Reluctantly I headed home for the three-and-a-half-hour journey. I arrived home weary from the week, and within an hour of being home, I received a call that Bronson had taken a turn for the worse. My heart felt crushed that I had left, and I immediately got back in the car to head back to Charleston.

Let me interrupt here to say that I hate driving. If I could fly everywhere, even if it was just a few hours away, I would. And driving in the rain is the worst. Of course, as soon as I got behind the wheel to head back to the hospital, it was a downpour

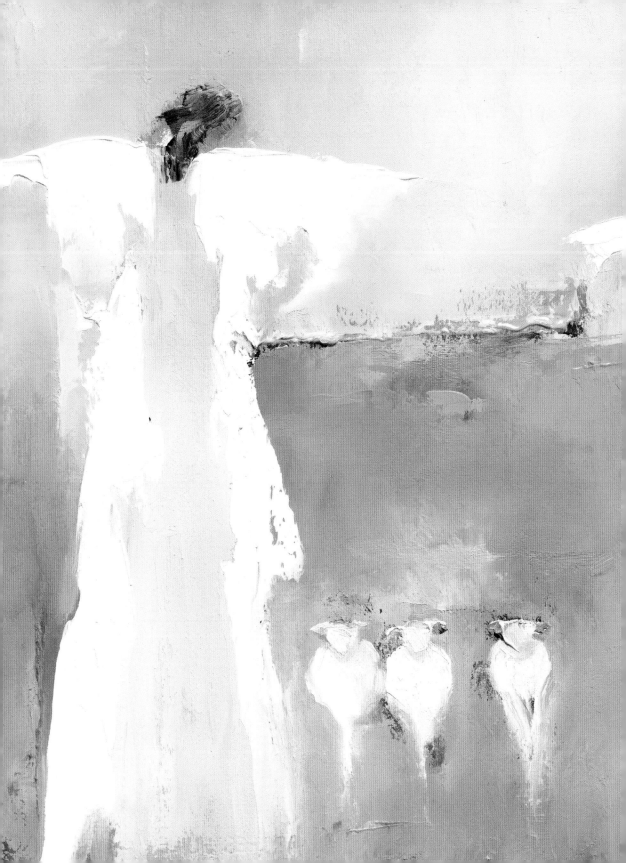

for the entire drive. *Tears from heaven*, I thought, and sobbed the entire drive to Charleston, crying out to the Lord to let Bronson hang in there until I got back.

I had hourly calls with updates as my hands gripped the steering wheel and tears streamed down my face. Tension rose from my toes to my shoulders. As I was about thirty minutes away from the hospital, I heard a still, small voice: *He was pointing to angels. Earlier . . . in his room . . . there were angels all around him.* Bronson wanted me to know this as he furiously pointed to something that he knew was there.

Just then, a peace that I cannot describe overcame my entire body and the tension was gone. The tears and sadness turned into this incredible joy.

He saw! And he wanted me to see!

I arrived within minutes of Bronson's passing. And I had a peace that I can only describe as supernatural, as it's the kind that only God can give in a time like that. Even in the midst of pain and loss, God showed up and surrounded my precious stepfather and his room with His angels.

To this day driving on dark, rainy nights brings me peace.

Angels. They are all around us. Always.

ANGELS.

THEY ARE ALL

AROUND US.

Always.

18

The Shepherd Knows Where to Find You

"Do not be afraid, little flock, for your Father has been pleased to give you the kingdom."

LUKE 12:32

By Sheila Walsh, television host, author, and Bible teacher

I will never forget the despair I felt as I drove to the psychiatric hospital in Richmond, Virginia. My worst nightmare was coming true—and there was nothing I could do about it. I had been battling depression for months, but the battle had finally overtaken me. I felt as if I was falling apart. All I could think about as I drove through the pouring rain was my wish as a child to grow up to be just like my father. That wish seemed to mock me now.

My father had ended his life in a psychiatric hospital when he was just thirty-four, and now I was almost the same age. A radical brain injury had turned my father from a loving dad to a frightening and ultimately violent stranger. As a five-year-old, I had no way to process the pain, so I internalized it, believing that there was something wrong with me.

I was eleven years old when my mother led me into a relationship with Jesus. She explained that just as Christ was now my Savior and Lord, I also had a heavenly Father watching over me. I remember so clearly thinking, *I have one more chance to get it right. Whatever my earthly father saw in me that made him turn against me, my heavenly Father never will. I'll be the perfect Christian even if it kills me.*

A NOTE FROM ANNE: I listened to Sheila Walsh's album *Blue Waters* throughout my last pregnancy. When the time came to deliver my son, Ford, I kept my eyes fixed on Jesus by playing *Blue Waters* throughout the delivery process. Twenty-one years later, I had the privilege of meeting Sheila in person when she interviewed me on her *Life Today* talk show. I could've spent hours with her, sharing all of our God stories. She is a gifted writer and speaker, and her music will be embedded in my soul forever.

It almost did. Decades later, I arrived at that psychiatric hospital while it was dark and still raining. I put my head on the steering wheel and wept.

How did I get here? How can you spend your whole life trying to get everything right and end up in a place that says everything's gone wrong?

A young nurse showed me to the room that would be my home for the next few weeks. I had never felt so lost, so alone. She told me someone would check on me every fifteen minutes during the night. I didn't even get into the bed. Instead, I took a blanket and sat on the floor in the corner of the room. I heard a voice at my door every fifteen minutes, but I never looked up. Then at three o'clock in the morning, the person didn't just stay at the door like before; they walked over to where I was, so I glanced up. It looked like a doctor going off-duty. He put something in my hands, something you'd give to a child—a little stuffed lamb. Then he walked back to the door, and when he got there he turned around and

said one thing, "Sheila, the Shepherd knows where to find you."

And then he was gone. I was there for a month and never saw him again. I believe that God in His kindness and mercy sent an angel that night to bring hope and light into my darkness. The Lord is my shepherd (Psalm 23:1).

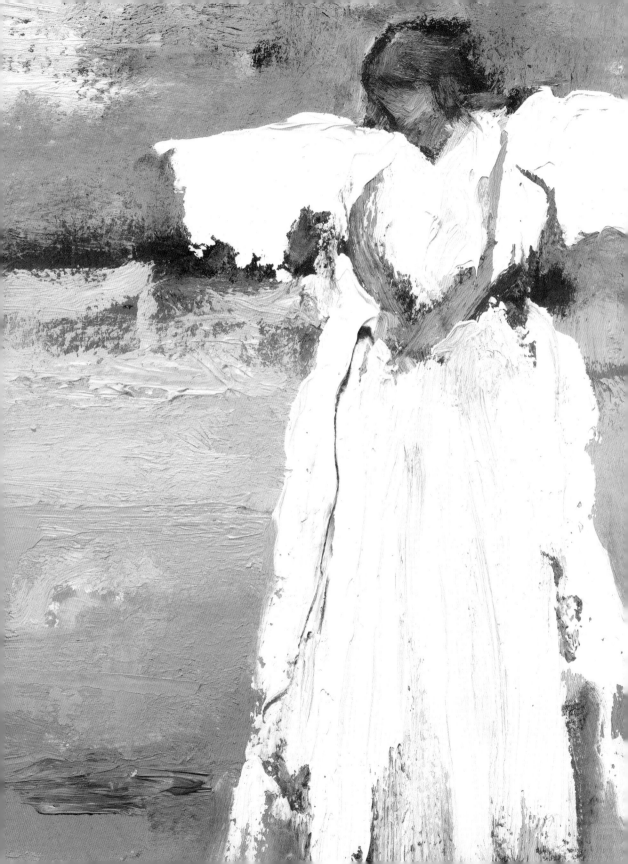

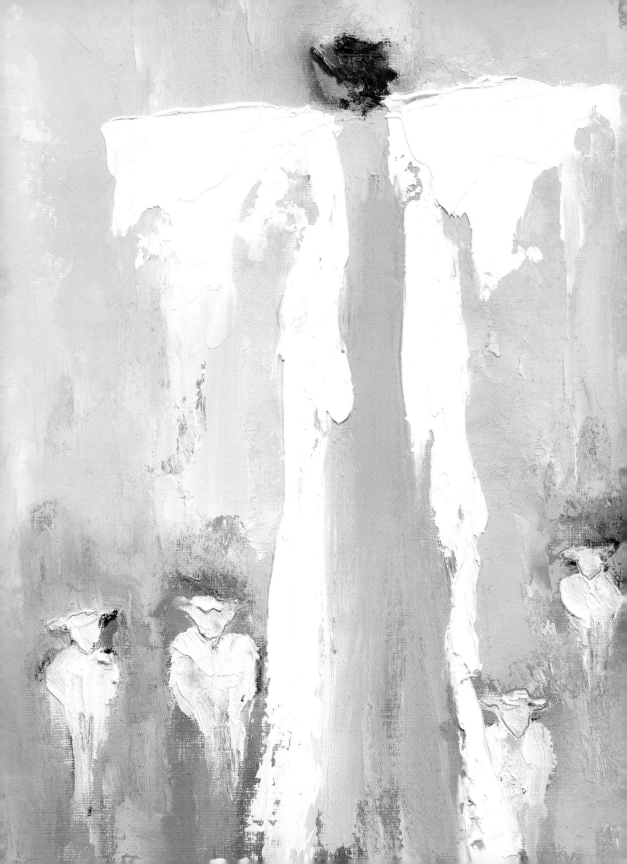

19

After the Storm

The LORD is good, a refuge in times of trouble.

NAHUM 1:7

By Anne Neilson

One of the reasons I'm writing this book is because each of these divine encounters is so meaningful to me. I remember each vividly, including one from August of 2005.

My family and I were in church, sitting next to a group of people I didn't recognize. They had just moved to Charlotte after Hurricane Katrina had wreaked havoc in New Orleans, including destroying their home and belongings. There were four of them, a lovely African American group worshiping God with their hands raised. (In our buttoned-up, noncharismatic Presbyterian church, we never saw this type of worshiping—ever.) They had just lost everything, and here they were in search of a new home, a new direction, and a new group of friends in a strange town seeking to start over. And then I saw these people who were temporarily experiencing homelessness reach down into their pockets, pull out dollar bills, and place them in the offering plate that passed by. The joy on their faces as they gave in the midst of their crisis brought me to my knees.

After the service my family was introduced to theirs, and it was an instant friendship. I asked Darren, one of our newfound friends, what he needed. He said that he desperately wanted to cook. He had been a great cook in New Orleans and missed the opportunity to cook and have a nice meal.

We had just built a house with a fabulous kitchen, so I asked him over to cook a wonderful meal. We set the date for a few days out and prepared the guest list. Darren didn't know it yet, but this was going to be a party with a purpose. Since the four New Orleans transplants had to start all over again, they needed everything from clothes to towels to pots and pans, pretty much everything we take for granted on a daily basis. So, unbeknownst to our new friends, each party guest was asked to bring something for their new home.

The day of the party, Darren and the other three arrived at my house, ready to cook. The entire house filled with the spicy aroma of Cajun jambalaya. When our guests arrived I was delighted at the generous, abundant gifts they brought. As our living room filled with piles of household goods, our friends from New Orleans couldn't believe it. They were overwhelmed and filled with gratitude.

We all sat at the kitchen table and listened as our guests of honor shared stories of their journey in the midst of the storm. We laughed and we cried, and we prayed that God would go before them in a mighty way and provide for all their needs, acknowledging that He is our provider no matter what we might be going through. I've noticed throughout my life how magical things happen around a kitchen table, and this time something extra special was happening.

We concluded the evening with Darren playing the piano and singing. As I sat there listening to Darren's thunderous voice belt out the words of songs that brought joy and glory to the Lord, I knew we were entertaining angels.

Magical
things happen
around a
kitchen table.

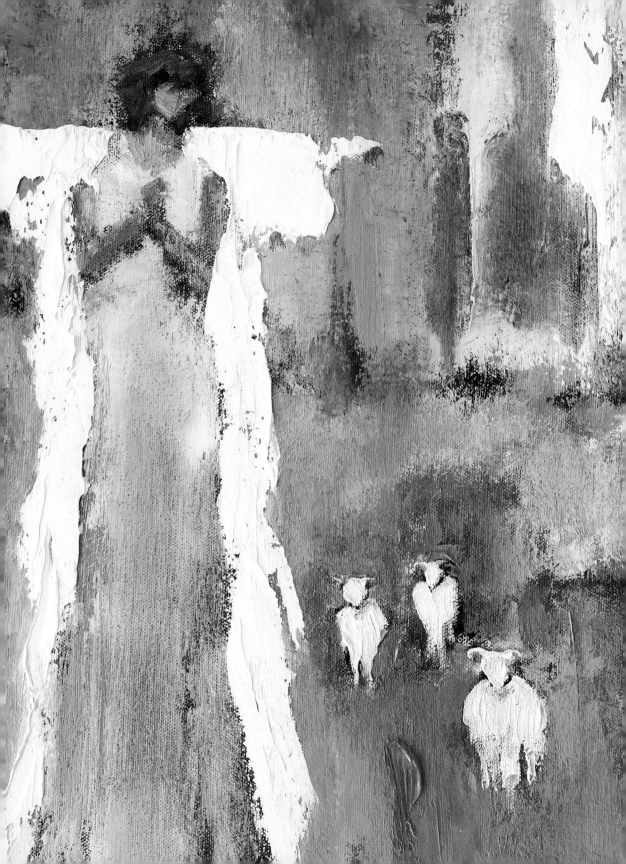

20

Sweet Whispers

"My sheep hear my voice, and I know them, and they follow me."

JOHN 10:27 ESV

By Teresa Hucko, author, equipper, speaker

As a director for a missions organization called Samaritan's Feet, I was privileged to lead teams around the globe, as we provided shoes and ministered to those in need. Carlos, one of my team members, grew up in El Salvador. He had received his first pair of shoes at the age of eight and that gift had meant everything to him. Now he was excited to serve on a team that gave shoes to children who were in need—just as he had been.

On a day when we were fitting and distributing shoes, I was sitting at one end of a long row of seats, and Carlos was at the other end. In an instant the Holy Spirit whispered to my heart: *Stop! And go take a photo of Carlos!* I sensed an urgency to get that photo *now*. I almost dismissed the voice as it made more sense for me to continue serving. But the whisper persisted, and I knew I needed to obey. And I am so glad I did!

I quickly made my way to Carlos. He was fitting shoes on a young boy. I asked the boy how old he was, and he replied he was eight years old. Then Carlos asked him

A NOTE FROM ANNE: I was invited to a luncheon at Samaritan's Feet and initially declined the invitation. But on the morning of the event, I woke up at 3:00 A.M. with this nudging: *You must go.* Tears flooded my eyes as I learned more about this organization's mission that day. The power and presence of the Holy Spirit was evident, and I was sold on this ministry that not only provided shoes, but served others by washing their feet and speaking hope and life into each individual. Teresa Hucko and her dedication to this ministry is a gift and a blessing to all those she serves.

his name, which also happened to be Carlos. At that very moment the Holy Spirit whispered to me again to take a photo of adult Carlos serving eight-year-old Carlos. Who better to encourage this young boy than someone who had had such a similar experience?

As big Carlos began to share his story, he became emotional.

"Don't cry. I'm happy. I'm getting my shoes today!" little Carlos replied.

"I know you are happy." Big Carlos knew *exactly* how that young boy felt, and they continued to have a very meaningful conversation.

I stand in awe of a God who cares about the individual. A God who knows our names and our experiences, and wants to encourage us. There were about four hundred children at this event and many others whom big Carlos could have assisted, but God wanted this particular boy to receive his encouragement. The chances of my getting up and taking a photo at the very moment big Carlos was with little Carlos were slim to none. However, I'm so glad I listened to that sweet whisper—maybe the whispers of an angel—and was able to capture the moment.

John 10:27 says, "My sheep hear my voice, and I know them, and they follow me" (ESV). I encourage you today to invite the Lord to speak to you. Then listen, obey, and experience the presence of the Lord at work—here, now, today—in your life.

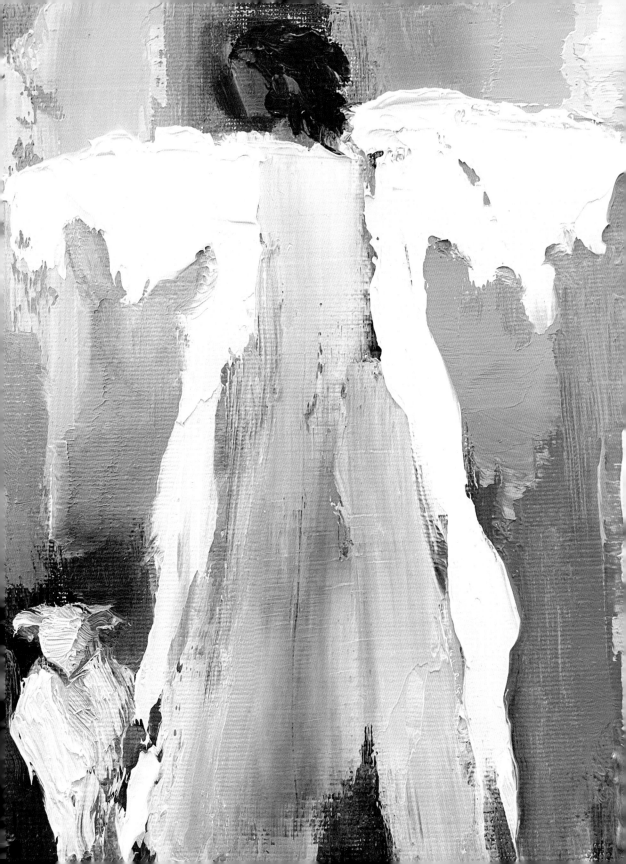

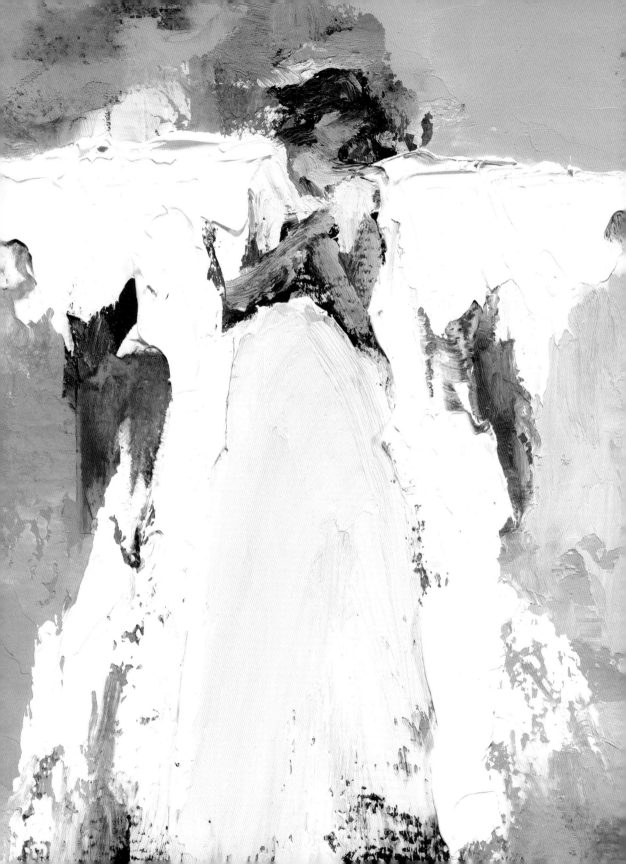

21

Let Go

"But blessed is the one who trusts in the Lord,

whose confidence is in him."

Jeremiah 17:7

By Anne Neilson

In 2004 some family in-laws came to visit us at our newly built home. Our children were young, and I was always trying to be a witness to my in-laws, who did not attend church on a regular basis. I am not one to preach a sermon or try to woo someone to faith through lots of conversation; I leave that up to my husband, who is more of an apologetic and can easily defend the faith. My favorite saying about sharing faith is, "Preach the gospel at all times. Use words only when necessary."[3] I believe our actions will attract people to us, and I don't have to say a word.

One Sunday morning we had talked our guests—my family members with their small children—into attending church with us. We'd had a deep discussion about faith over the weekend—how imperative it is, how it differs from religion, and how it's about having a relationship with Jesus on a daily basis—just like you would with anyone you care about. I remember how, as I was getting ready for church, my heart felt deeply troubled for this family. While drying my hair, a song popped into my head and it wouldn't go away. Then

I heard the whisper: *In your actions of worshiping Me, today I want you to surrender and trust. Raise your hands in surrender, give this family to Me. Let go. Trust.*

The song played louder and louder in my head, and my mood shifted from being discouraged to being filled with joy, knowing that as we plant the seeds—whether through actions or words—God will do the watering and all the work to woo the hearts of His beloved.

We went to church and lined up all our kids and their cousins in the pew, ready for worship. I've mentioned before that we attended a Presbyterian church, a denomination sometimes categorized as being the "frozen chosen"—many members never raised their hands in church during worship. I, on the other hand, would fling my arms up in worship any time *outside* this church. But there . . . well . . . I would just stand along with others, appearing a little frozen even though my heart and soul were on fire with praise and worship.

This day was different.

The praise band started playing the song that had kept playing over and over in my head earlier. My spirit knew and was nudged. *Raise your hands. Worship Me. Trust Me.* It was the same whisper I had heard in my spirit earlier that morning. And with that, my hands shot up into the air, and the tears streamed down my face.

It can be incredibly difficult to let go and risk being different, while trusting the One who gives every good and perfect gift. I don't know if my expression of praise brought about spiritual curiosity or created room for others to follow suit, but in that moment I needed to obey.

To trust. To wait. To see.

I realized I just needed to trust God with the matters of my family and their faith walk and stop trying to control the outcome. I'm only responsible for my own faith and obedience. And though we don't always know how our witness affects others, God sees them and watches over them.

Raise your hands.

Worship Me.

Trust Me.

Project 120

For we are God's handiwork, created in Christ Jesus to do
good works, which God prepared in advance for us to do.

EPHESIANS 2:10

By Anne Cochran, wife, mother, author, and intercessor

One of the first times I knew I had seen an angel was on December 26, 2014. I was at the mall, of all places, shopping for ornaments the day after Christmas. It was early in the morning, and after making a purchase I headed to the escalator to leave. Out of nowhere a woman appeared and got on the escalator ahead of me. She wore torn lavender corduroys and a tan jacket. Her hair was noticeably disheveled, but her Crocs were as white and as clean as any I had ever seen. It was odd seeing what appeared to be a homeless woman on the escalator so early in the morning the day after Christmas. Yet my mind began swirling, wondering how to approach her to offer a gift card as a blessing.

This had become a habit of mine, carrying around gift cards to bless those who seemed to be in need. As I rummaged through my purse, I remembered I had cleaned out my wallet the day before and the Chick-fil-A gift card was on my dresser at home. I glanced up as the escalator approached the exit floor and realized the

woman was gone. I looked to the right. I looked to the left. There was no one on the floor that I could see. The store appeared totally empty, and the woman had vanished.

While walking to my car, I began asking the Lord if I had just seen an angel, and if so, why? It was then that I heard Him speak to me in the way I often hear His voice. *Anne, I am pleased with your heart's desire to help and give. I have an idea for you. I want you to go buy ten Chick-fil-A gift cards the beginning of January. During the month I will show you whom to give the gift cards to. I want you to do this the beginning of every month for the next twelve months. By year's end you will have given away 120 gift cards, and this will be the subject matter for your next book. The title of the book will be* Project 120.

A NOTE FROM ANNE: In August of 2000 my new friend Anne Cochran asked if I wanted to join her for a prayer meeting at a local church. That night changed my life and the lives of six other young women on a deeper journey with God. It was at Anne's house where I felt the angel's hands on my eight months pregnant belly. Anne has been a warrior for Christ, listening to His still, small voice—always testing His voice against the noise of this world.

You can imagine my surprise. I was completely overwhelmed with excitement and also in awe of what was happening. I had had a desire to write another book and had been praying about it. But nothing had come to mind on what to write about. *God's idea,* I thought, *was brilliant!* I drove home, told my husband, Rob, what had happened, and promptly went out and bought ten gift cards. On January 1, 2015, I was ready to watch, listen, and hand them out as the Lord directed.

What transpired over the next twelve months was extraordinary. I ended up documenting a dozen of the stories and self-published my second book, *Project 120*, in 2016. God's way of getting me involved sure was creative. He invited me into this

yearlong project by putting an angel in front of me on an escalator in a mall. Angels are real, and they have many assignments. They are always in our midst.

I learned that day that when we are open to seeing angels and ask why they are showing up on our path, God can use them to usher in a life-changing adventure. I am thankful for the Lord's creative ways to get our attention when He has an assignment for us, and I am thankful that sometimes these ways involve angels.

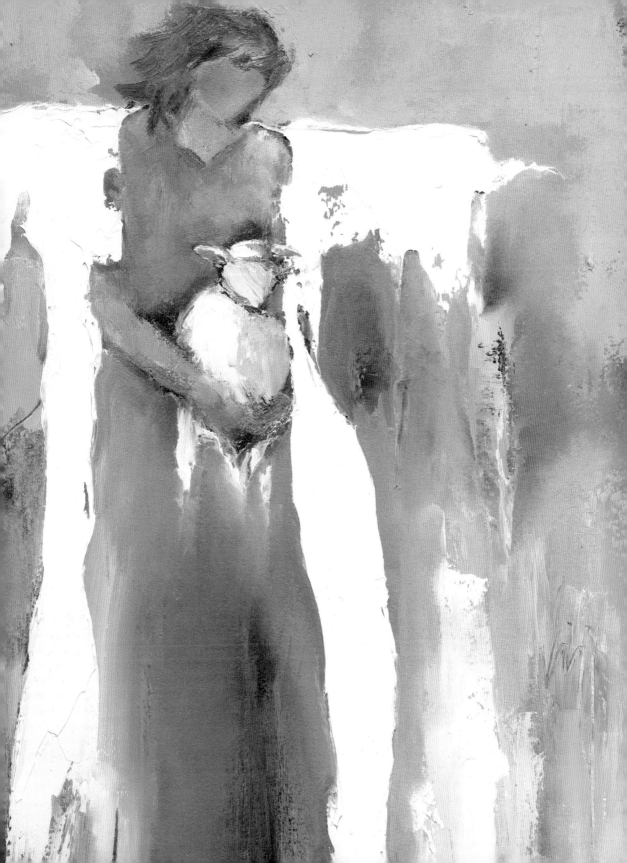

23

Apple Pie Lady

*Human beings ate the bread of angels; he
sent them all the food they could eat.*

PSALM 78:25

By Anne Neilson

*H*ow far would I go to apologize? What was I willing to do to say "I'm sorry"? Would I drive more than eight hours round trip in one day just to get face-to-face with the person I needed to reconcile with?

Honestly? I don't know.

In the early years of running our business, my main employee, Wendy, ran the show. She knew everything that went out product-wise and everyone who had placed orders. She knew the orders that were damaged, and she knew the orders that were supposed to go to one address and mistakenly got shipped to another. She emailed countless customers and assured them that we were on top of their orders, despite any hiccups or delays. Needless to say, she was efficient in getting our angels out the door.

We were working late one Friday afternoon when the front door of our offices flung open and a bubbly customer wearing a bright green sweater came in, with two

What started
as a ministry
to serve others
also *ministered*
deeply to me.

white boxes in hand. The aroma of freshly baked apple pie quickly filled our dusty warehouse studio, and Wendy and I looked at each other, perplexed.

Did we know her? Did we miss something? Did she have the wrong address?

Nope. The woman told us her name and that she had driven from Atlanta, Georgia, to deliver two homemade apple pies as a peace offering. Wendy and I were confused. The mystery customer went on to explain that she felt so bad for sending us a snippy email when she was frustrated with her order, and she wanted to come in person to apologize.

Wendy recalled the order and never thought for a moment that there was anything this customer needed to apologize for—but did that mean we would give up this amazing peace offering? Not at all. Instead, we opened the boxes and practically drooled right into the pie tin before diving in. The three of us stood in my office, talking and sharing, laughing and crying, and connecting deeply on some of the impactful and powerful stories of how our angels had touched so many people. And I realized: what started as a ministry to serve others also ministered deeply to me.

We spent a while in my office, and after she left to drive four hours back to her home, Wendy and I looked at each other with raised eyebrows.

"Wow. What just happened?"

Here's what happened: someone we didn't know took the day off from her job and drove eight hours round-trip just to be kind and to apologize. She was an angel in our lives that day—one who helped us redirect and reflect on our mission of service.

Thank you again, sweet Apple Pie Lady. I can still smell the aroma of those delicious homemade pies, and I can still see you walking through our door in your bright green sweater, grinning and with a heart full of grace.

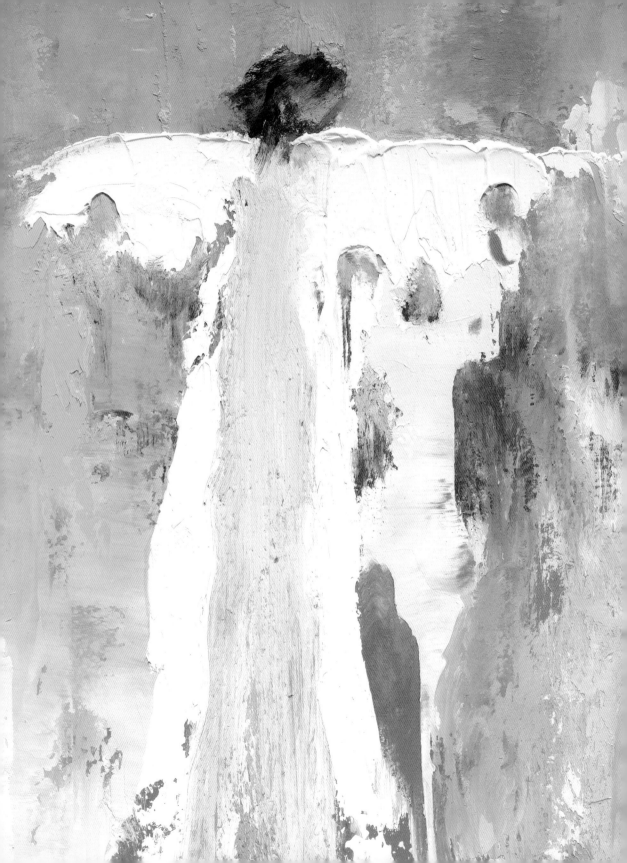

24

Caught Off Guard

Jesus answered, "I am the way and the truth and the life. No one comes to the Father except through me."

JOHN 14:6

By Carol U. Gamble, prayer warrior

I
n the fall of 1999 I began attending a women's Bible study with a dear friend. I knew there had to be more to life than what I was seeing, and I had an aching in my heart for more. Perhaps this was where my questions would be answered!

Shortly thereafter, some difficult things took place in my life: my mother became unable to take care of herself, and she had to move out of the house my parents had owned for more than fifty years. It was a sad time for me to see my mother ravaged by Alzheimer's. And all the new-millennium craziness was beginning that fall as well.

However, in the midst of that craziness, I felt more peace than I ever had. I was learning about Father God and His amazing love for me. I was studying the Bible like never before. Every week I would attend my small group and challenge my leader about her belief in God, asking *how could Jesus be the* only *way to the Father?* I would weep during the lessons, as if hearing about God for the first time in my life. Even though I had gone to a religious school for more than ten years, for the

A NOTE FROM ANNE: Carol is one of those people who walks into a room and all heads turn. She's strikingly beautiful and graceful in every way. I remember the first time I met her at our Christmas Bible study brunch over twenty years ago. She was sharing her testimony to the group of women. What I did not know that day was that Carol would become a lifelong friend and prayer warrior in my life.

first time, my *heart* was listening, not just my brain.

The new year and new millennium came, and the world didn't end. I continued attending Bible study and at some point purchased a worship music CD—*Blue Waters* by Sheila Walsh. Over and over I listened to the anointed music, and my heart began to soften even more.

I attended Easter service with my small group leader later that spring, and I felt like I was seeing the celebration of the resurrection with new eyes. My understanding of the cross of Christ was becoming clearer. My face was slowly turning toward the truth of God, His love, and His Son, Jesus—sent to earth to be the perfect sacrifice for my sins.

I even asked my small group leader, as we walked up to the door of her church on Palm Sunday, "Nancy, do you really believe Jesus Christ died on that cross for my sins and then rose from the dead?" She looked directly at me and replied, "Yes, Carol, I really do believe that Jesus Christ died on that cross and rose from the dead!" Deep down inside, I knew she was telling me the truth.

My first year of Bible study ended in late spring and I was so encouraged and had met so many wonderful women, I signed up for the next fall session. As the summer approached, I started taking my three young children to the local farmers market every week. We had so much fun picking out local produce, and the people were so friendly.

I remember a specific day like it was yesterday: I had purchased so much produce

that I needed help to my car. At the checkout, a nice young man offered to help me. Since I had a big watermelon among other things, I took him up on the offer. We walked to my Suburban, and he loaded everything inside the back of my car. Then he turned around, looked me straight in the eyes, and asked, "Do you know Jesus Christ as your Lord and Savior?"

I was completely caught off guard. "What?"

He asked again, locking his eyes on mine. "Do you know Jesus Christ as your Lord and Savior?"

I stammered and said, "Well, uh, yes!"

"Are you sure?"

And I confidently said, "Yes!"

"Okay, have a nice day!" he said, and then walked back to the market.

I was speechless. I smiled and climbed into my car to drive home. *Wow, that man was bold*, I thought. But I was also intrigued and pleasantly surprised.

So the next week, when it was time to go shopping again, I looked for him everywhere. He was nowhere to be found. Every week I returned to the market, always looking for him, and I never saw him again. Was he an angel sent by God to ask me for a decision? Romans 10:9 says, "If you confess with your mouth that Jesus is Lord and believe in your heart that God raised him from the dead, you will be saved" (ESV).

Later that summer, I heard the gospel preached by an anointed evangelist. I stood up and came forward to receive Jesus as my Lord and Savior, and then I received the baptism of the Holy Spirit with the laying on of hands. I was overwhelmed by the love of God, and His power surged through my body! I knew that God and Jesus were real and loved me. And I knew the power of God was in me and I would never be the same.

I am forever grateful to that young man or angel who was bold, caught me off guard, and demanded an answer.

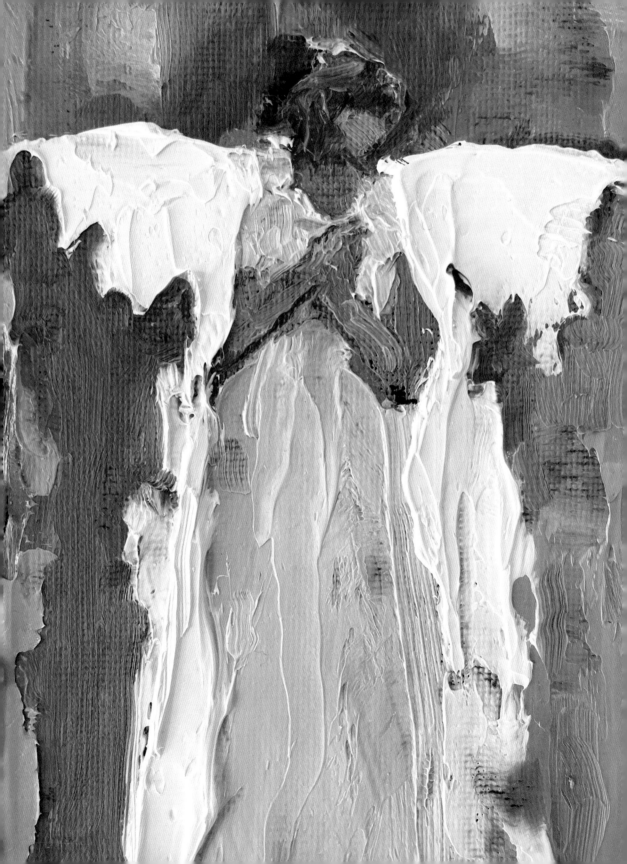

25

Wrong Turn

I will instruct you and teach you in the way you should go.

PSALM 32:8

By Anne Neilson

My husband and I spent a month in San Diego during March 2021. That month of California living was great! We rented a cherry-red convertible and explored all over the city.

One sunny Sunday afternoon, we were on a quest to find the Pacific Coast Highway with dreams of cruising along the coastline, wind whipping through our hair—or at least mine, as Clark has only a few these days. But somehow we ended up getting way off course, turning right here and left there and eventually ending up on a cul-de-sac in a fine neighborhood. We quickly turned our car around and noticed two women out chatting in the streets. By this point I wanted to get out of Dodge—we screamed *tourists*—but my husband gave a friendly smile to these two neighborly women and asked, "Hey, where is the Pacific coast?" I think he meant Pacific Coast *Highway,* but that's what these women heard. Perplexed, they walked over and pointed, "It's right there!"

Of course we knew exactly where the ocean was, but that prompted my husband to

I arrived to the most *magical* day ever. Angels were everywhere.

continue the conversation. "Do you live here? What are some things that we can do as tourists?" And eventually, "Hey, my wife is an artist; let me show you some of her work!"

By this time I wanted to slip my foot over the console, press the pedal, and *go*, but too late. We were engaged, and they were very kind women. We exchanged our information and thanked them and went on our way.

The next day I woke up to a lovely email from our new cul-de-sac friend. She mentioned that she had a group of women who were all artists and would always get together and travel with one another and paint. She would love to host a luncheon for me and introduce me to all her friends. Since I was out in California for a month and didn't know one person there, the fact that this precious woman wanted to have a party for me was touching.

The date was set, and I arrived to the most magical day ever. Angels were *everywhere*. Not supernatural ones—but angel ornaments, angel food cakes, angel cookies with reproductions of my angel art printed on them in edible ink, angel-hair pasta, and even angel napkin rings. The view of the Pacific coast was breathtaking. The table set for fourteen was elegant, and her home showcased beautiful art throughout from all of her friends.

We spent the morning and part of the day sharing stories around the table. Each of the artists shared a little about their painting. We were all unique and different, yet with the same heart and soul of an artist.

I love how God places people in our lives at just the right times—when we need a little encouragement from a friend, or we need to feel celebrated, or we just need to lean on one another. As God's Word says in Proverbs 27:17, "As iron sharpens iron, so one person sharpens another."

That day that we got lost, God had in mind a reason for it. The stranger in the cul-de-sac was an angel in my midst. She became a dear friend, and I will be forever grateful for the hospitality of our new friends in California, and for God who goes before us—even when we turn left instead of right!

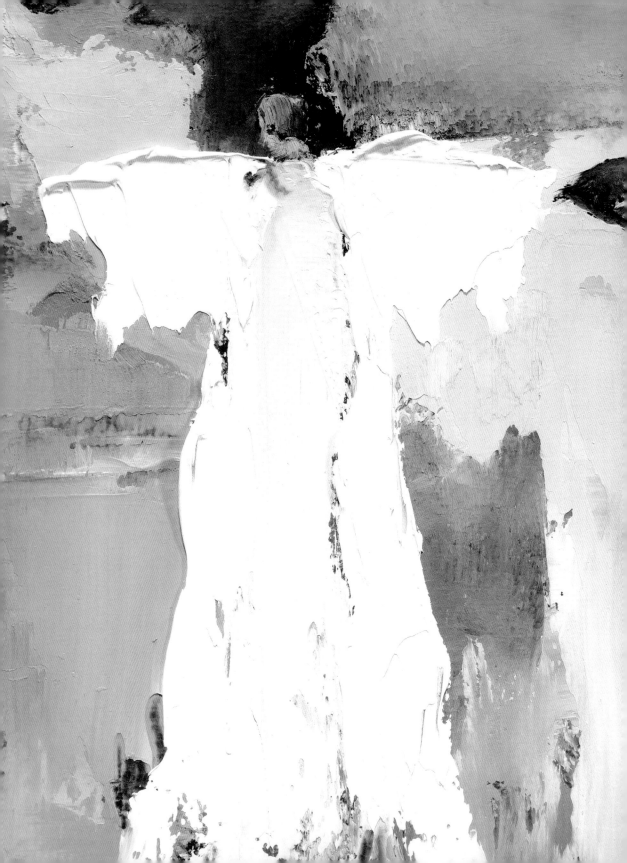

26

Angel-Powered Steering

Keep me safe, my God, for in you I take refuge.

PSALM 16:1

By Lisa Clark, author and speaker

*D*ear Jesus, please surround this car with angels—on the hood, the bumper, the roof, and in here with us. Please keep us safe as we travel. In Your name we pray, amen."

That was the prayer my mom had been saying with me since the first time she'd tentatively allowed me behind the wheel at fifteen years old. Ten years later I was still saying that prayer every time I got into the car and before turning the ignition. Those angels traveled some serious miles with me in that time—all over the world, in fact. I could always "see" them in my mind's eye, their enormous, feathery wings blowing and billowing in the wind.

One night, well after midnight, while I was living in Los Angeles, I was driving home on a four-lane road I'd traveled countless times. Two lanes to my left, there was a sheer drop-off to the beach below. Traffic was light at that hour, so I was surprised when my windshield was suddenly filled with harsh, bright light. I instantly recognized the light was coming from headlights—headlights that were in *my* lane. The

A NOTE FROM ANNE: I love to say that God weaves His people together for a higher purpose. As my agent and I were sharing stories about this new devotional on entertaining angels, she mentioned that her good friend Lisa Clark, who happens to be an author, had a powerful story to share. I pray that you are blessed by what she shares.

car was accelerating, bearing down. I instinctively called out to the Lord for help, saying, "Jesus Christ!" But the voice did not sound like my own; it had a deep, guttural tone. It was a cry that emanated from deep inside my soul. The steering wheel turned so hard that I remember wondering if my SUV was going to roll over. The impact came. My world turned black.

I was okay. The other driver was okay. Both cars were totaled. The police officer said, "You know, it's a miracle you didn't go over that ledge. I can't figure out how you ended up over here, and not . . . down *there*. Your guardian angels must've been working overtime tonight."

"Yes, officer," I said, "they certainly were."

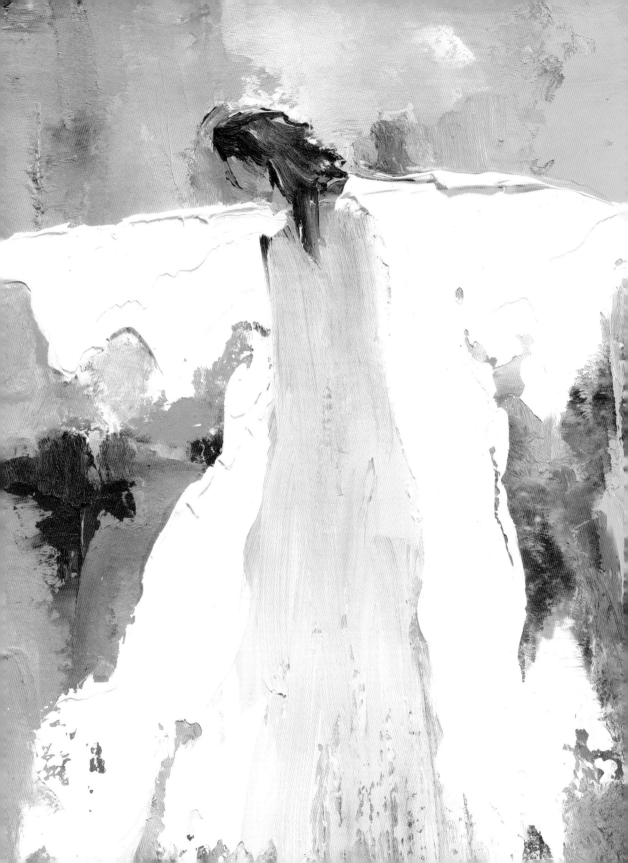

27

Outward Bound

*Where there is no guidance, a people falls, but in
an abundance of counselors there is safety.*

PROVERBS 11:14 ESV

By Anne Neilson

I received a phone call from my dad one day that something special would be coming in the mail. The next day I received an envelope that contained my journal pages from 1987 . . . typed . . . on a *typewriter*! My dad saves every little letter and note, and I had forgotten all about this journal.

It was a detailed description of the ten-day intensive Outward Bound course I had taken in the summer of 1987. Reading through this poignant, unedited version, tears filled my eyes. And then I chuckled. It's funny how when you read something so distant, from so long ago, the memories can come flooding back and are suddenly right there with you.

I was twenty-four years old and trying to figure out what to do with my life. You might not know this about me, but I was not the greatest student. In fact, I got a D minus in tenth grade art. I'd like to say I was coloring outside the lines and my art teacher wanted to rein me in. . . . Regardless, school was not my thing. I later went

116

to Florida State University for a year and a half and discovered that college was not really my thing either.

After college I came home and immediately started working, trying to figure out what God wanted me to do with my life. I had known as a young girl that I wanted to be an artist; that was clear. I loved to create, and I loved selling whatever I was creating at the time—but I never could pinpoint exactly what I was *called* to do.

I started with fashion and worked at a small boutique for a while. But still nothing. No satisfaction. I tried to get my real estate license, but that involved studying, so that didn't work for me. Then I worked at a mortgage company and really felt like I had moved on and up, starting as a file clerk and then quickly moving into an office with a riverfront view. Now this was something. I even took a few business trips to check out the REO (real-estate owned) properties and to document their conditions. But I still felt like there was something missing.

One day my dad told me about this Outward Bound trip, that I should do it and that it would be fun. Now, I do like an adventure, so I decided to sign up for the ten-day intensive course in the North Carolina mountains. I wanted to go and "find myself."

There were twelve of us on this trip. I was by far the youngest but was determined to enjoy every minute. On the first day we were told to share only our first names and one thing about ourselves, but we couldn't tell anyone our last names or what we did for a living. This was all we were to know about one another. Natasha who likes pink, Bob who likes to hug, John who likes to cycle, Sharon who likes to take pictures, Perri who likes tennis, Gloria who likes to eat, David who likes to sleep, Stuart who likes to cook, Eddie who likes bees, Linda who likes horses, Gena who also likes horses, and Anne—that's me—who likes to ski.

Over the next ten days, we shared, hiked, navigated through rain, picked

blueberries, slept under the stars, rappelled down steep mountains, trusted one another, and bonded. One of the girls, Gena who likes horses, had me in stitches most of the trip. I loved her personality. I loved her outlook on life. And I found myself gravitating to know more about Gena and what she did in life. But the rule was we could not know anything about the person. Lips sealed.

The last night we were at camp, our leaders had each of us write our last name and our profession on a piece of paper. The papers were folded up and placed in a bucket, and one by one the leaders would pull out a piece, read the last name and job description, and we would have to guess who it was.

I wish I could remember Gena's last name. All I can remember was that she was a third-grade teacher.

That's it! That is what I'm going to do!

Gena didn't know that she was an angel for me every day as we laughed and picked blueberries. As we challenged our way through rocky paths and navigated back to camp in the dark, she was my angel who made me believe in myself once again. She encouraged me to try, even if it was going to be hard. She helped guide me when I felt lost.

I ended up going back to college and graduating from Jacksonville University with an elementary education degree and taught third grade for a season. God was faithful in the journey, and I'm grateful He placed Gena on my path.

God was

faithful

in the

journey.

28

Hush Your Rush

The plans of the diligent lead surely to abundance,
but everyone who is hasty comes only to poverty.

PROVERBS 21:5 ESV

By Gwen E. Smith, host of the Graceologie *podcast, coach, speaker, and author of* I Want It All *and* Broken into Beautiful

It was dinnertime, and I was in a rush to grab what I needed from the grocery store. While there, I ran into a casual friend. She was at the store because her Crock-Pot had mysteriously stopped working that day. She had loaded it up in the morning, plugged it in, turned it on, but it never heated up. The chicken was still raw and certainly would not be edible come dinnertime.

It wasn't in my plans or on my calendar to run into this person. But when we met at the corner of eggs and pretzels, it wasn't a coincidence. It was an appointment set in God's calendar, one I had no idea I was just on time for. We both were.

Sometimes God sends angels. Other times God sends you and me.

It turns out this friend was someone who looked put together on the outside but was being pulled apart on the inside by a heart-wound that dripped of fear, insecurity, and doubt.

God's Spirit guided the conversation between us. Both she and I knew it by the divine traces of grace, truth, and peace that covered our hearts as we said goodbye through tears and a hug. We smiled as our carts crossed paths again at the checkout line, each of us knowing we had come for groceries but were leaving with what we needed even more.

I was filled with a fresh measure of gratitude and an overwhelming awe of our loving Plan Changer, who knows and responds to the needs of our harried hearts. He had sent me a personal and on-time word through the lips of a friend.

The grocery ground we walked was holy.

Deeply humbled, my thoughts soared with God's beyond-ness. The way He met us there. The way His agenda trumped mine. The way a Crock-Pot stopped working as part of a greater dinner plan. The way He loves her. The way He loves me. The way He loves us. Oh, how He loves us! Perfectly. Immeasurably. Personally.

My earlier rush was hushed as I loaded bags into the trunk and left the parking lot. The steering wheel felt chilly, but my soul felt warm with God's goodness. I reflected and gave thanks—so much thanks. I was grateful for the invasion of His presence . . . of His agenda . . . of His grace.

Joy rode home with me and hung out that entire evening. I was changed because my plans were rearranged. Because God needed to make His love known to a

A NOTE FROM ANNE: Gwen came into my life around 2002, when I was leading a small group Bible study. Every Wednesday morning, Gwen—tall, strikingly beautiful, and transparent with her testimony—led us in the most beautiful worship time. Gwen's music later became a huge part of my painting process. Her grace and words of wisdom—filled with the power of the Holy Spirit pointing to His grace—have taken her on an incredible journey as a musician, author, and speaker.

discouraged daughter—and because He allowed me to join Him in the beautiful mission. God always invites us to join Him at work.

I'm desperate for this lesson to linger longer. Are you?

Proverbs 16:3 tells us, "Commit to the LORD whatever you do, and he will establish your plans."

When your day is rearranged or those plans seem ruined, open the eyes of your heart in expectation that God may have penciled you in for a special appointment. He does that, you know, in tender, mysterious ways—sometimes even through a faulty Crock-Pot.

29

Trust the Whisper

After the earthquake came a fire, but the LORD was not in the fire. And after the fire came a gentle whisper.

1 KINGS 19:12

By Anne Neilson

Some days I will pick up just about anyone who has a homeless sign and wants help. And this day was one of those days. (Caution: please do not do this unless you are 1,000 percent sure that you are being led by the Holy Spirit.)

On the corner of a well-known intersection in my town, a pregnant woman held up a sign: "Homeless. 3 kids. Please Help." I passed her and went on my way to the store, where I was headed to pick up groceries for my family. At first I didn't stop. I thought, *It doesn't matter; I shouldn't feel guilty.*

But I did.

I made a U-turn and wheeled my car around to see the pregnant mom still on the side of the street. I motioned for her to walk a block down to the gas station. She obliged, and we met in the parking lot. I rolled down my window and asked a little bit about her. I believed her story and felt the Holy Spirit move and whisper, *Pay for her rent.* I didn't even have much cash with me but kept feeling the nudging: *Pay for her rent.*

I could've easily given her the twenty-dollar bill I had and moved on, but something in me kept tugging on my heart. *Pay her rent.* She had not even mentioned that she needed money for her rent, but I asked anyway.

"Where do you live?"

She told me about her family and where they lived. The next thing I knew—and this is the thing I caution you to do only if you're sure the Holy Spirit is nudging—I told her, "Hop in the car. We're going to take a little ride to the bank." I asked her how much her rent was. It wasn't that much, so I withdrew enough to pay two months of rent. We came back to the gas station and I prayed for her as tears streamed down her face. I hugged her goodbye and dropped her off, praying for her as she disappeared down the road.

As I retold the story to my family and friends, I got a big scolding that I had been scammed. Maybe I had been; maybe I hadn't. All I knew was the gnawing at my spirit to pay her rent. I could've ignored the whisper, but I didn't. And I don't know what happened to her or the money I gave her, but I trust that God had urged me to help provide for that pregnant mom's needs—scam or no scam.

People experiencing homelessness have a big pull on my heart for many reasons. I believe that we have been given so much and have the responsibility to give back to those who struggle. Every homeless person is someone's son or daughter, and ultimately they are all God's children. We don't need to know or understand what has happened on their path of life, but we can always choose to be an angel in their midst and to entertain the angels all around us.

Trust the whisper when you encounter someone who has little and needs much.

We can choose
to be an angel
in their midst
and to *entertain*
the angels all
around us.

30

Heaven-Sent

*"I have spoken to you of earthly things and you do not believe;
how then will you believe if I speak of heavenly things?"*

JOHN 3:12

By Christina Spillars Meadows, owner of Quintessentials

On a sunny Friday in late March 2021, my dad, Mike, went to meet his friend Harvey for lunch. Harvey and Dad had been friends since elementary school and both were granddads. The two had been looking forward to lunch after a year of the COVID-19 pandemic keeping get-togethers at bay. They met at Harvey's house, and Dad joined him in the car for the drive to lunch.

They never made it. They were hit head-on by a drunk driver. Both were killed. State troopers assured us they died instantly. One moment they were enjoying life and the next minute they were with Jesus. There was nothing Harvey could have done to avoid the driver in his lane, and there is nothing that can prepare you for that news. Our families are still reeling and in shock.

Almost three months to the day of my dad's death, I received the sweetest note from a young woman named Madison, who stopped at the accident. She couldn't have known that she sent me that note on my birthday. This brave young woman

stopped at the scene before the first responders arrived. She was in nursing school and wanted to help. She, along with two other men who had also stopped to help, checked both cars to see what they could do. Though she could not offer medical assistance, she held my dad's hand and prayed for him, not knowing he had already taken his last breath.

A NOTE FROM ANNE: I met Christina in 2013 when I had stepped out in faith and was preparing to open an art gallery. Though we had discussed the possibility of her becoming the gallery manager for Anne Neilson Fine Art, she eventually became the owner of a store in Raleigh, North Carolina, that would later sell our angel products. Hearing the powerful story of her father's passing, I asked her to share this angel story—a powerful moment where God sent an angel to hold a hand.

The magnitude of this act is immeasurable. Madison held the hand of the man who had held mine so many times: while playing in the ocean as a little girl and, more recently, while walking me down the aisle. His hands were always there to hold mine whenever I needed it. That this young woman could hold his hand, pray, and show such compassion is an act beyond words.

I am so incredibly grateful for that gift and am impressed by Madison's courage, compassion, and strength. Coincidentally, Madison was also the name of our beloved chocolate Lab—our family pet, but truly my dad's dog. Dad would have loved that connection, but I know he would have been even more in awe of her kindness and compassion. I believe the Lord finds ways to show you His love and faithfulness, and Madison—along with her gesture and her note—were truly His gifts to me.

After I spoke with Madison, I asked Harvey's children if they had heard about

her. His son said, "Only that someone said she was an angel." We all feel she was heaven-sent.

My mom, brother, and I met Madison to thank her and to get to know her a little bit. She is absolutely someone my dad would have loved. She's smart, strong, and sweet. We shared stories and learned about her family. And though there were tears, I smiled when she used salt and pepper on her salad before her first bite: a Mike Spillars signature move. It was perfectly fitting.

Madison will always be a part of our family. She is in our prayers, and we look forward to seeing all she does in life being so young but also so strong and so filled with a heart that serves the Lord.

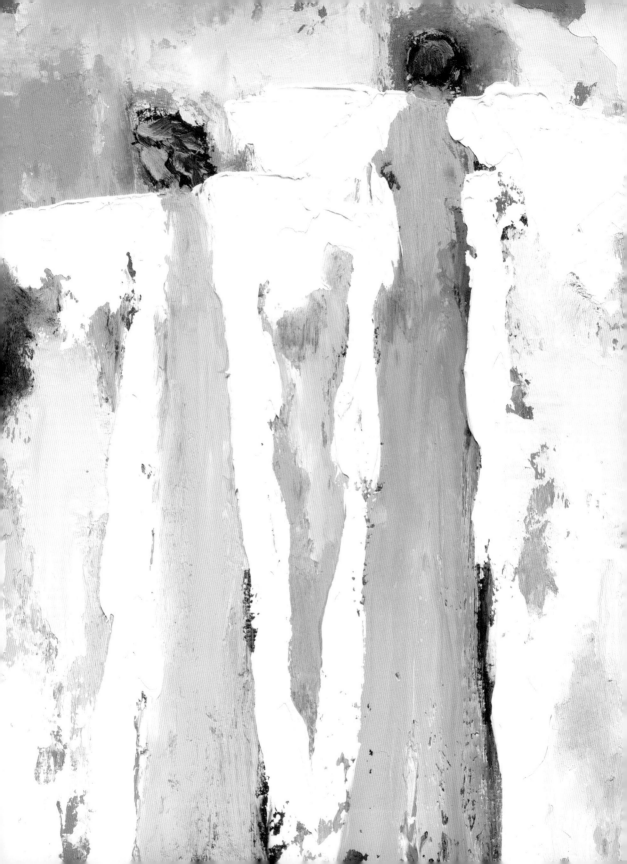

31

Harvest Center

*And God is able to bless you abundantly, so that
in all things at all times, having all that you need,
you will abound in every good work.*

2 CORINTHIANS 9:8

By Anne Neilson

uring the second week in December one year, my gallery team signed up to volunteer at the Harvest Center's annual coat and toy giveaway luncheon. The event was designed to serve those who needed extra help—and it landed on what turned out to be a bitter cold and dreary day.

Moms, children, and neighbors experiencing homelessness were coming from all parts of the city in hopes of getting a coat for the cold winter months ahead. I can't remember how many families the Harvest Center had planned on serving at the luncheon that day, but when we arrived there was panic among the volunteers. They were afraid that there were too many people and not enough food—or toys or coats, for that matter.

I kicked into Santa mode and called Jimmy John's to order another fifty sandwiches. I asked them to please slice them into thirds instead of halves, to increase the

food for the masses. The guests would wait in line to pick up a sandwich and a drink, listen to the inspirational message, and receive the toys and coats. I kept hearing that not everyone would get a toy or a coat, and they had to ration the goods due to the overwhelming response from the city. As I was serving the food, I noticed a very young mother with four very small children. She was calm. Poised. Good manners. I heard her tell her children to say "thank you," and I watched her as she managed and rationed the food, giving up hers so that all of her kids would be satisfied.

I noticed. I watched. I was amazed.

Shortly after all the food was given out, and after people gathered their items, the volunteers were cleaning and getting ready to close up for the day. The sky grew darker and the rain kept drizzling, the persistent kind that eventually cuts to the bones.

I walked outside and saw one of my employees talking with this same mom I had been observing the entire morning. She was desperately trying to get a cab in the rain. Her kids were crying because they did not get a coat—or a toy. She kept telling them it would be okay.

As I approached this family, I asked where they lived and if they wanted a ride. She took me up on my offer and all eight of us (five of them plus my two employees and me) piled into my little car that legally buckled seven. Off we went to take them home. As I pulled out of the Harvest Center, I asked, "We are celebrating Christmas in a few days; does anyone know what the true meaning of Christmas is?"

"Yes! Yes! Yes!" they all cried out. "It's all about Jesus!"

I looked back in my rearview mirror with a grin and agreed that it was, and that He is the real reason for the season. I then said, "Hey, we are going to take a little detour and head to Walmart for a little shopping spree. Toys, coats, anything you want!"

The excitement on these precious children's faces was the best Christmas gift that anyone could ever give me.

We hopped out of the car and grabbed four shopping carts and then put one child into each. We walked up and down aisles getting toys, clothes, and necessary items. The sweet mom only wanted some new pajamas and underwear. I forgot to mention that she was pregnant with her fifth child.

She shared her story. Her past. Her mistakes. She desperately wanted to live a life free from the chaos of sin, but she felt trapped and didn't know a way out.

I told her that God is watching out for her, and He does so by putting events and people in her life to help her along the way, that He loved her, that He did have a way out for her, and that she needed to surrender and trust in a living God who has plans for her to prosper and be filled with hope.

About an hour into our little shopping spree, I noticed I only had 1 percent battery charge left on my phone. I was coming around the corner to meet the mom on the other side of the aisle and just stopped in my tracks as I saw her on the phone. A little voice whispered in my spirit: *Someone has been shot.*

What? That doesn't make any sense! I silently argued back.

As I walked closer her face went pale, and she said that her boyfriend—the person she was living with—had just been shot at their apartment.

There happened to be another angel in the store that day—an off-duty officer, getting a cold drink from the cooler near the checkout counter.

I approached the officer and shared the story with her, and she immediately radioed in for details. She confirmed the events, told us police were swarming, that they put up yellow tape to ward off everyone. We were advised *not* to go back to the scene of the crime.

I found my employees with their carts now piled high with goods and wondered,

What now? Where will we go? How do we cram all of our loot into my small car? This will never fit. What will happen to this family?

I chatted with the officer, and we all decided that I would put this family up in a hotel across the highway. We paid for our items, piled into the police car with all the toys and coats and more, and headed across the highway. We got the family set up for a weeklong stay and encouraged the young mom to call her own mom and go home—not to her home of the past few months, the one filled with danger and uncertainty, but to the home where grace and forgiveness abides.

We opened the door to the simple but nice one-bedroom, one-bathroom hotel room, complete with a kitchenette. And the excitement on these kids' faces, you would have thought they had just won the lottery and abided in a palace!

I'm not sure what happened to this family. One of my employees kept up with her for a few months after, and we do know that she did end up going to her mom's home, but the rest is in God's hands. *Psst!* It always is!

As we left them in that hotel, my heart felt full knowing that through a nudge from the Holy Spirit, followed by a divine intervention—or an appointment is how I like to think of it—we all partnered with God and moved this family out of harm's way.

I NOTICED.

I WATCHED.

I WAS

amazed.

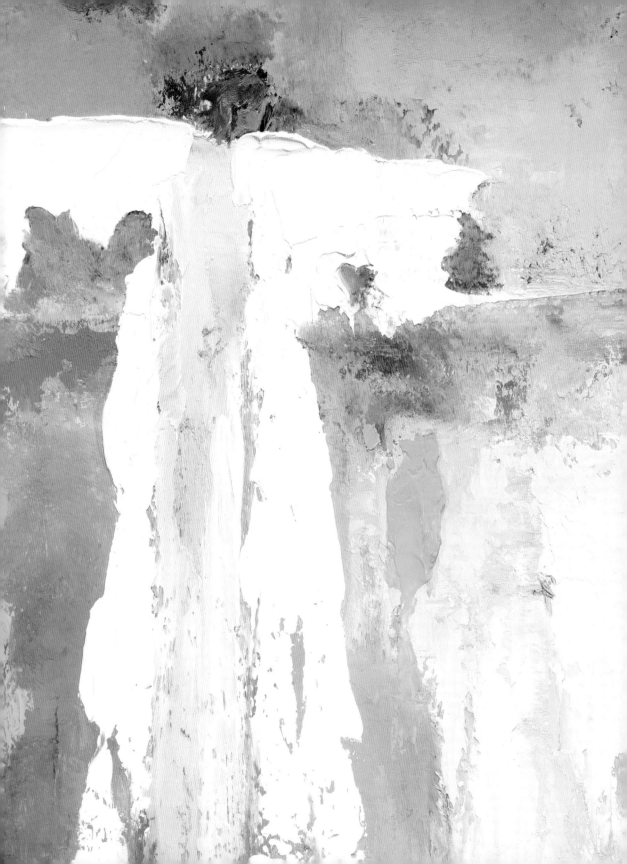

32

The House on Briarbridge Lane

My people will live in peaceful dwelling places, in secure homes, in undisturbed places of rest.

ISAIAH 32:18

By Gigi Harris, wife, mother of four, and community volunteer

There's little evident grace in the midst of a young child's cancer diagnosis, so when we got the devastating news that our three-year-old daughter, Margaret, had a metastatic brain tumor, we expected none. We needed to go to Duke Medical Center in Durham, North Carolina—about a two-hour drive from our home in Charlotte—for advanced treatments, and when we got there, we stumbled into the cheap hotel across the street from the hospital.

The Brownstone Inn looked like its name: exterior walls the color of mud, shag carpet in the lobby a slightly darker brown, everything in the room a little damp and sticky with the faint odor of old cigarette smoke. The effect on a scared family's mood: glum and glummer.

But then a glimmer of comfort came from a phone call. Our friend Nina called

A NOTE FROM ANNE: I remember the pink bumper stickers precisely placed on the cars driving around Charlotte, North Carolina: a plea for prayer for a little girl named Margaret and her fight for life. I met Gigi Harris, Margaret's mom, a few years later. The pain of losing a child runs deep and wide. But we serve a God who can come into every nook and cranny of the loss and fill the cracks with hope. Whenever I see Gigi she radiates the evidence of His light and His love even in the midst of pain and suffering.

to tell us that her mother had a little place in Chapel Hill, eight miles away, and wanted to make it available to us while Margaret was undergoing treatments. Before we could decline, for fear of adding more cost to our mounting medical bills, Nina said it would be free and she had already arranged for delivery of a house key.

The house on Briarbridge Lane looks like its name too: a cottage surrounded by flowery brambles in a circle at the end of a shady street, with windows letting in the sun, a galley kitchen, comfy couches and easy chairs, colorfully and cheerfully decorated. Like a home.

So we stayed there during many visits for treatment at Duke. We even invited friends over, along with grandparents and godparents, had family meals, watched *Reading Rainbow*, infused medicines, cried a little, prayed a lot, and found peace during a painful time.

Our daughter ultimately lost her earthly struggle. The pain of her loss is not gone, but it has faded over the years.

The memories of the moments of grace have started exceeding the hurt, and we remember the angels. Like Nina's mother, Ann, whose generosity provided some light that dispelled the darkness for a time.

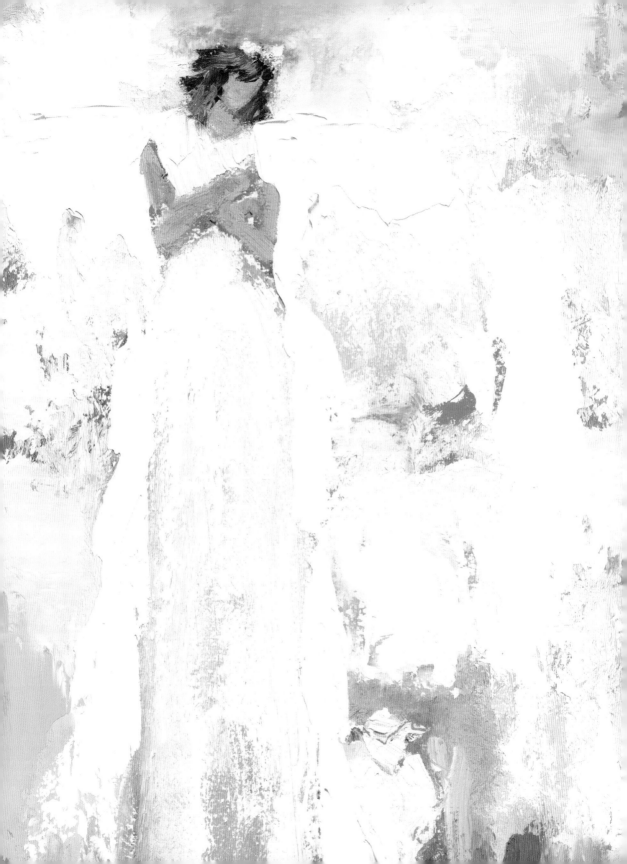

33

Sold Out

Finally, all of you, be like-minded, be sympathetic,
love one another, be compassionate and humble.

1 PETER 3:8

By Anne Neilson

My favorite date night used to be having an early dinner and then heading to the movies, where we'd snack on salted, buttery popcorn and watch a movie on the big screen.

One particular date night my husband and I went to our most frequented theater to purchase tickets. "Sold out." Every movie we wanted to see was completely sold out. Frustrated and determined to see a movie, we looked up another theater that was about ten miles away and saw that if we put the pedal to the medal (which Clark is notorious for doing), we would only miss the previews. The previews happened to be my favorite part in the movie-going experience, but we would at least make it in time for the movie.

So off we went.

It was getting dark, and as we turned onto the main road—a busy one—we saw a woman struggling in her wheelchair down the sidewalk . . . alone. We zipped past

her and then started wondering whether she needed help. It was dark, after all, and the sidewalk was bumpy. Where could she be going? There was something tugging at my heart to stop. *Turn. Go back.* We decided we should see if she needed help.

We headed back to find the mystery woman and then pulled into the driveway of a church. We parked and walked down the driveway to find her. She was weary, out of sorts, currently experiencing homelessness, and unable to walk. We told her we would wheel her up and get her help. She mentioned she was out of Depends and was trying to get to the nearest drugstore for her sanitary needs.

As we prowled around the dark church to see if anyone was around, we noticed some lights on in the back rooms. And just as if God had arranged this entire scenario, the church was hosting an event called Room at the Inn, and they welcomed this woman into the warmth of those walls.

Clark went to the nearest store to get her needs, and I stayed and set up her sleeping space for the night. She was a little disoriented, but through the amazing volunteers and warmth at the church, she was able to settle in to a safe, warm space. I sat as she lay there and asked if there was anything I could do. She said, "My mom always rubbed my head and brushed my hair to calm me down. Would you rub my head and brush my hair?"

Tears flooded my eyes as I reflected on my selfishness from earlier, wanting to zip past this woman on the street and get to my movie. I remembered the fact that this was someone's daughter, someone who grew up and no longer had a mother to comfort her or bring her peace.

I brushed her hair, and tears continued streaming down my face as I recounted the steps of the night and how God had orchestrated the events. *What if our movie had not been sold out? What if we had not taken that right turn onto the busy street? What if I hadn't listened to the still, small voice that said,* Turn around?

I know I've missed a lot of opportunities in my life. So many times I've let the noise of the world drown out the voice of the Lord. But this dreary, cold night, I listened. We may have helped her for only one night, but I know that God will provide for the rest of her days. Like many of my stories, I'm not sure what happened to this woman from the busy intersection, but my heart will be forever changed as I had the opportunity to sit with her, stroke her hair, and speak words of truth into her.

"You are worthy," I told her. "God loves you."

YOU ARE

worthy.

GOD

LOVES YOU.

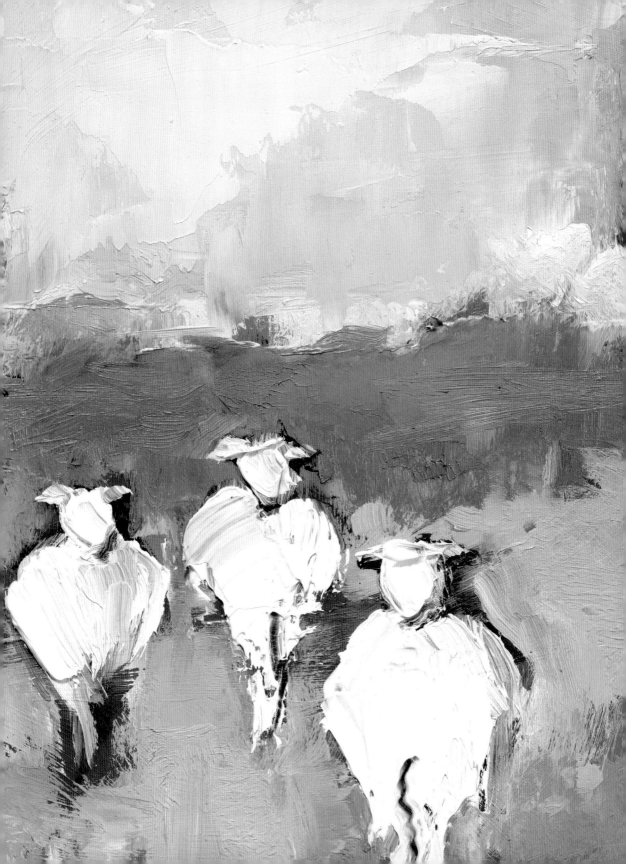

34

An Evolution of Faith

"In the same way, I tell you, there is rejoicing in the presence
of the angels of God over one sinner who repents."

LUKE 15:10

By Anne Ferrell Tata, author and politician

Living in a military town offers a wonderful benefit to a family with four
children: nannies! Every year an influx of young military men and women
arrive in Southeast Virginia to serve their country. They are often accompanied
by spouses. It's not easy for some of the young wives. Some find the transition to
military life to be filled with unexpected difficulties. Their lives are transient. They
never know when they may be transferred. Deployments are stressful. Spouses can
be gone for six to eight months. We were able to offer employment in a home envi-
ronment, which offered comfort.

One of our best nannies was a young woman named Rebecca. She was no-
nonsense, hardworking, and reliable. She worked for us for about two years. Eventually
she met a young military man, and they began dating. Michael had enlisted in the
Navy right out of high school and had tested so well, the Navy selected him for a
special program. They paid him to attend college, and after receiving his bachelor's

A NOTE FROM ANNE: Anne Ferrell Tata and I grew up together in Jacksonville, Florida. She married after college and moved to Virginia Beach, Virginia, to start her family. We exchanged Christmas cards every year and later connected through social media. Around 2010 I received a message that she was coming to town and would love to have coffee. We really didn't know much about each other anymore—and certainly nothing about our faith journeys. Anne arrived at the coffee shop promptly at 9:00 A.M. We sat and shared, mostly about God and His faithfulness, and we didn't leave until six o'clock that night. What a day of reconnecting!

degree, he could be commissioned a Navy Officer. We immediately liked him. Our children were full-swing in activities, school, sports, music, and more.

For extra money, Michael offered to help with carpool duties. He was a godsend. We were grateful for the extra set of hands. As we got to know him better, he opened up about his family and career. He was the eldest son of a single mom, and he was responsible, conscientious, and self-sufficient. He also was an atheist. Things were going along well for Michael until two major setbacks. The first involved Rebecca. She and Michael had been living together, and she became pregnant. After she gave birth, she brought her baby to work. Occasionally, Michael stepped in when Rebecca was sick. As time went on, Rebecca became more and more unreliable with more frequent sick days. Sometimes she would call and cancel, and other times, simply not show up. Michael did his best to cover for her, but there was only so much he could do. Finally, I had to let her go.

I was about to begin a search for a new nanny when Michael called me and asked if I would hire him. He explained they needed the money, and he was able to handle the sole responsibility. I was relieved and accepted immediately. With my

flexible work schedule, I could work my hours around his school schedule, which fluctuated each semester.

Around this time, I was attending a women's Bible study. I eagerly sought opinions of my new Christian friends on how to live out my Christian life. Regarding household help for children, they felt strongly that anyone in your home who had access to your children must share your belief system. In other words, they would not have allowed a non-Christian to babysit.

I became insecure about our nanny situation. I wasn't confident enough in myself or my relationship with Jesus to admit to my Christian friends that not only were my nanny couple not believers, they were living together and had just had a child out of wedlock. I tried to push away my feelings, but it was easier to compare myself to these Christian women, and to believe I didn't measure up.

I felt conflicted. I had no complaints with Michael. His military training suited our chaotic household. He was never late and up for any task.

But I let him go. He was confused but accepted my decision.

The next day I made a visit to Regent University, a private Christian university located in Virginia Beach, and placed a "help wanted" poster on their message board. Within a week I had the perfect candidate. She was working on her masters degree in elementary education. She loved the Lord and led a Bible study. I was so excited! She began the following week and we bonded over Scripture and prayer. However, from the first day, there were a few tiny red flags. I overlooked them because I wanted it to work. I stood up at my Bible study with a praise report to share my great blessing! I now had a wonderful, godly young woman taking care of my children.

A few weeks after she began working, I came home from work and found her sitting in a chair with my two-year-old son on her lap. She was holding a blood-soaked

paper towel to Robert's cheek, frightfully close to his eye. Horrified, I grabbed him out of her arms and asked what happened. She casually informed me that he had flipped out of the backyard swing and his cheek hit a rock. I called a close friend who is a plastic surgeon and rushed Robert to the surgeon's office. Robert ended up with five stitches.

I couldn't sleep that night. I tossed and turned. I replayed the scene over and over. I was grateful Robert's eye narrowly escaped the rock. I wondered why my nanny had not called me immediately. I recalled other instances that by themselves might not have been a big deal, but collectively now caused great concern.

By the time I headed to work the next day, I was not only physically exhausted, I was mentally drained as well. I went straight to one of my favorite customers, Angela—a godly woman and dear friend who was also a confidante. Sitting in front of her, reciting the details of the day before, I saw the horror in her face. Hearing the words come out of my mouth made it real. Immediately Angela told me to get that woman out of my house! I protested a little, but Angela was firm. It was as if she was giving me a metaphorical slap in the face.

I bolted out of her office and ran to my car. I will never forget the urgency and panic I experienced as I raced down the highway for the thirty-minute ride home. Once home, I thanked the young woman for her time, while announcing that I would no longer need her services. I slept like a baby that evening.

The next morning, I called Michael.

Once again, the peaceful and productive rhythm of life returned to the Tata house. Kids were well taken care of, Bob and I were progressing in our jobs, Michael was a champ and agreeable to assist us in every way. He never asked why I let him go; therefore, we never discussed what had happened.

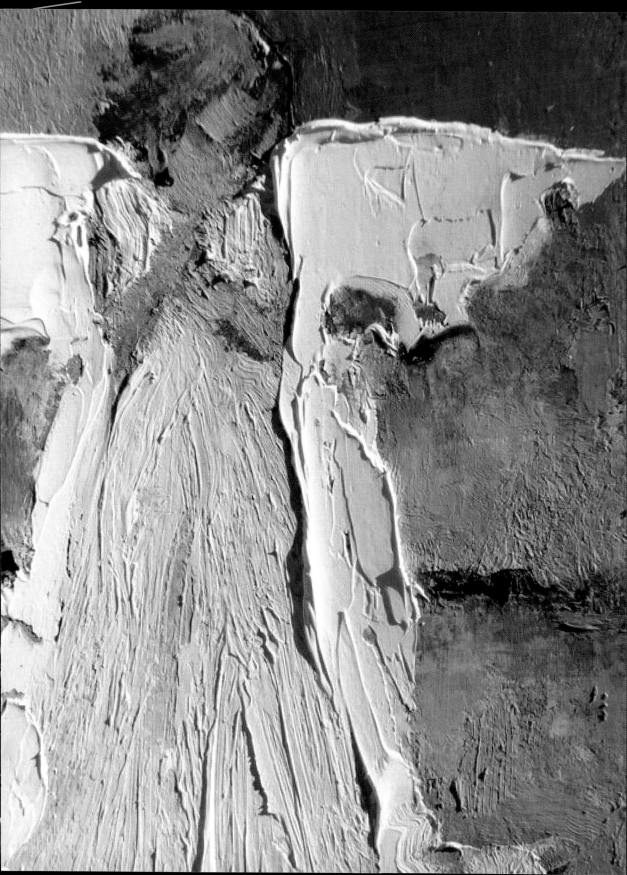

One afternoon, a few months later, we were going over the schedule for the upcoming week. I casually and lightheartedly referenced him as an atheist.

He looked at me and said, "I don't know if I would call myself an atheist. I would describe myself as agnostic."

I couldn't believe it.

"Are you serious?" I questioned.

And then he said something that I will always cherish for the rest of my life because it evidenced a door God had opened that no man could ever close.

He said, "Do you think I haven't noticed the books and quotes you have around your house? Do you think I haven't picked up a few to read?" I looked him in the eye and smiled the biggest smile.

"What? So does that mean you are open? Does that mean you'll listen to a tape?"

In those days most cars had cassette-tape players in them. There were some wonderful recordings and discussions on evolution versus creationism. Michael believed in evolution. He agreed to listen, and I sent him home with a six-part series on why evolution is false. The following week he announced he no longer believed in evolution, but he wasn't convinced the universe and living organisms originated from the God of the Bible. That was okay. I knew it was a terrific start.

I felt God say, *Pause*. He brought the story of Samuel to my mind, the prophet who addressed all of Israel. He was old and God used him to announce and anoint Saul as the Israelites' king. As Samuel stood before his people, he reflected on his years in service on their behalf. He said, "Now stand here quietly before the Lord as I remind you of all the great things the Lord has done for you and your ancestors" (1 Samuel 12: 7 NLT). God reminded me about everything He had done for me, my family, and my own ancestors.

He loves us. He guides us. He desires communication and relationship with us. He wants more from me than to only surround myself with like-minded believers.

He wanted the same for Michael. Michael continued to work for us, and we continued discussing the ins and outs of faith. He had lots of questions, and while I didn't always have answers, I did my best to respond or refer him to additional resources. Eventually, he received his bachelor's degree from Old Dominion University. He and Rebecca had two more babies, and he received news they were going to be transferred out of state. He invited us to his college graduation and asked Bob to perform his commissioning ceremony, a ceremony when an officer trainee or, as in Michael's case, an enlisted officer trainee transitions to a commissioned officer. Then he announced he and Rebecca were getting married. We were overjoyed at all his news! Bob was particularly honored to be asked to administer the oath of office for Michael. What a thrill to watch Michael have his epaulettes (or shoulder boards as some people call them) placed on his shoulders.

Our family attended all of Michael's momentous events. We were proud of him and his hard work. We were also sad to see him go. Before he left, I gave him a personal letter that concluded with, "Please promise me that *when*, not *if*, you accept Jesus Christ as your Lord and Savior, I will be among the first people you call!"

I kept in touch while he and his family traversed coast to coast on different military assignments. And I continued to pray knowing that it was a matter of when and not if!

Finally, one day, Michael called to tell me had accepted Jesus Christ and he was transferring back to the Hampton Roads area. Unfortunately, by this time, he and Rebecca had divorced, and he had married someone new, a woman named Hannah whom Michael knew from his past. Michael and Hannah had been best friends in

high school and had remained close over the years. It didn't turn romantic until long after their subsequent divorces.

We invited Michael to dinner when they arrived in town so we could meet Hannah. His family joined our church, and their children immediately plugged into the youth program. Our minister discipled Michael, and it warmed my heart to watch him grow in his faith. After several months, Michael called to ask me to be his witness at his baptism.

The night I had let the Regent student go, slept like a baby, and decided to call Michael to come back to work, I had had a long conversation with God. I asked why it had happened. Why had the Regent student not worked out? Was He not listening when my Bible study friends told me what to about a non-Christian in my home? I reminded Him that I had asked my Christian friends for guidance. In His still small voice, He reminded *me* that I had not asked *Him*!

I learned from this experience to ask God first.

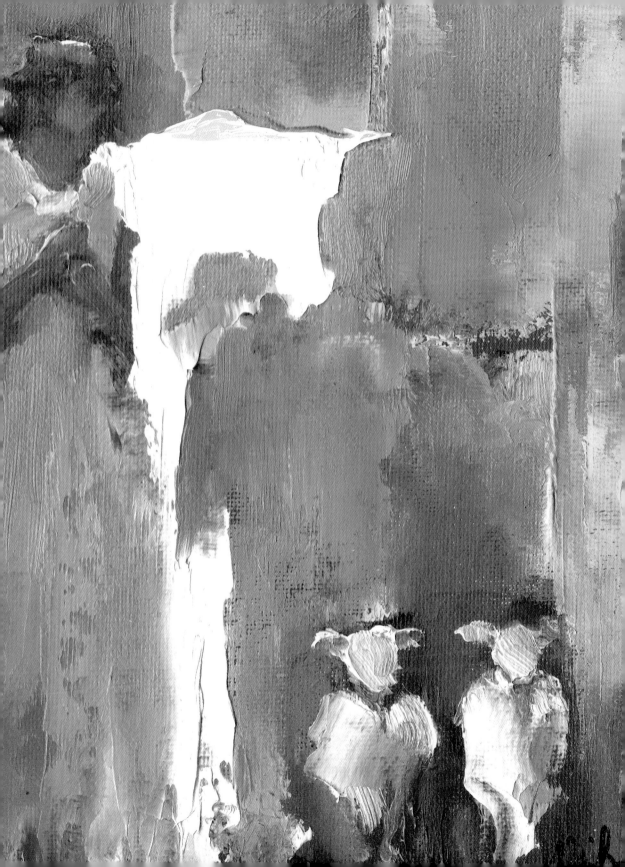

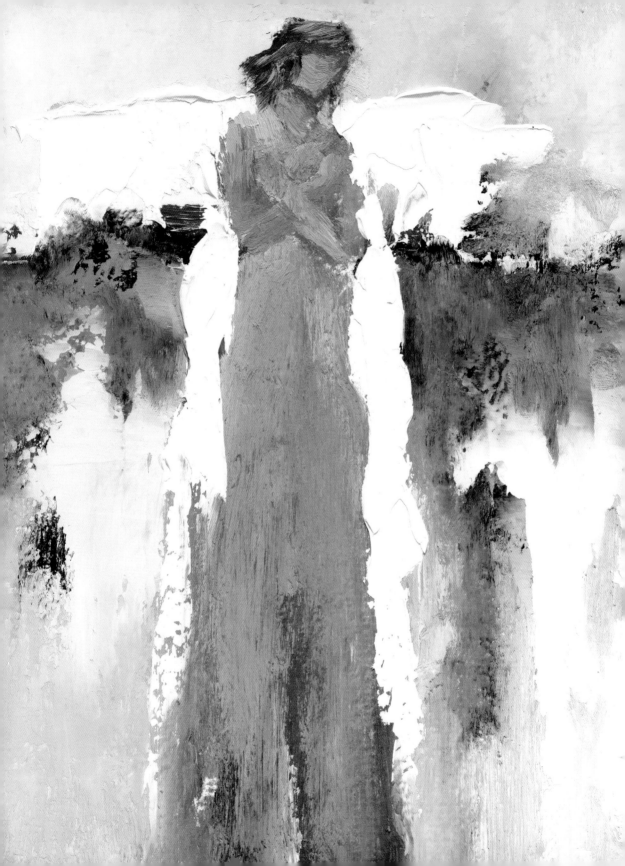

35

My Mother's Story

*"The LORD your God is in your midst, a mighty one who
will save; he will rejoice over you with gladness; he will quiet
you by his love; he will exult over you with loud singing."*

ZEPHANIAH 3:17 ESV

By Kathie Lee Gifford, actress, author, and singer

Y ou would never have known it from my mother's joyful, beautiful exterior,
but the truth is she had one of the saddest, most heartbreaking childhoods
you can imagine.

Her mother died of tuberculosis when she was two. Her only brother, Alfred,
died of measles when he was three, and her broken, alcoholic father died of despair
when she was only nine years old.

Death seemed to dominate her world.

But then she and her older sister were sent to live with their disabled, elderly
grandmother. This period of her young life was a brief season of happiness, but
too soon it ended when her grandmother suddenly died, leaving her and her sister
Marilyn completely alone—and homeless.

She was fifteen years old.

A NOTE FROM ANNE: I love how God weaves together an unexpected, beautiful friendship. That happened in 2012 when Kathie Lee Gifford showed up at my gallery exhibit in Essex, Connecticut. About an hour into the show, Kathie Lee walked into the gallery on a dreary evening in an unfamiliar town. From that very first interaction, I learned that her faith ran deep. This story she shares about her mother is a powerful reminder that angels surround us always. Can you hear their voices singing over you?

I remember my mother describing this time in her life and it always moved me to tears. So much loss in such a short time with so little childhood joy.

But suddenly one day in their apartment, soon after her grandmother's death, my mother heard the most magnificent, joyous music fill the room. Heavenly music. Divine beyond description. It was an angelic choir. She knew this without a doubt, and she got so lost in the pure, profound beauty of it, she thought her heart would burst. Slowly, the celestial sound faded away, but it left her a beautiful gift.

From then on, my mother understood that heaven was real and all of the loved ones she had lost were a part of it.

And it gave her peace and hope for her life to come.

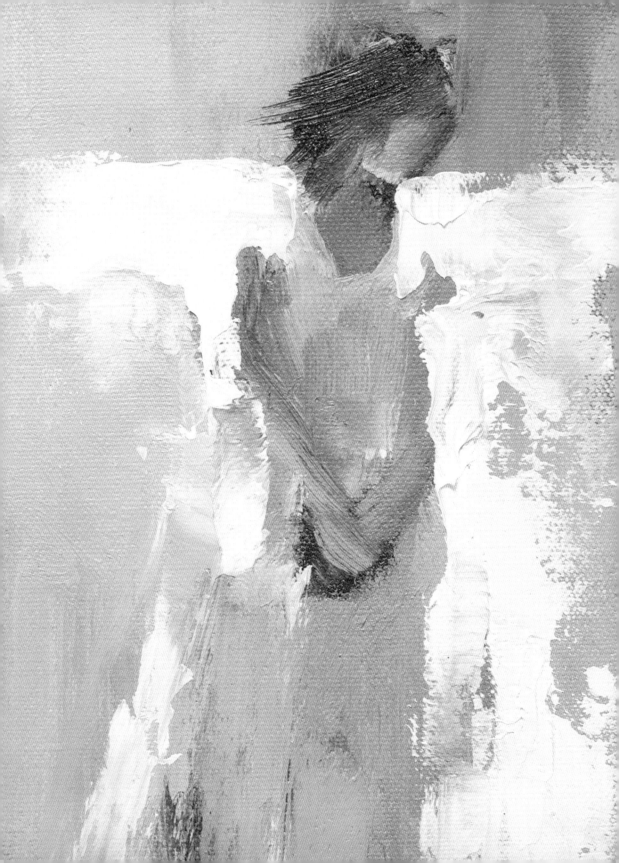

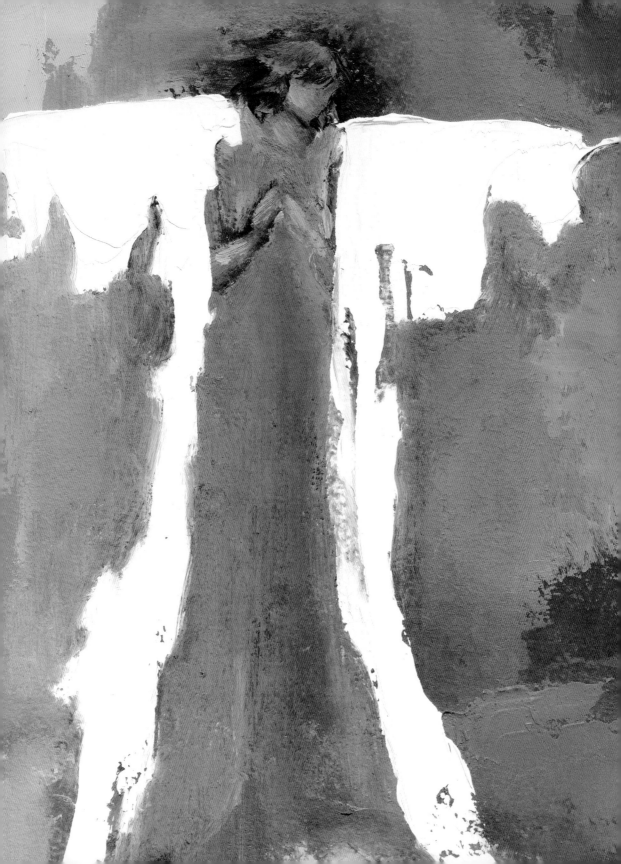

Afterword

For centuries artists have portrayed angels as beautiful beings with whimsical wings and a glowing light—some adorned with halos, some depicted playing a harp or a violin, some with translucent, flowing white gowns, or—as I like to paint these ethereal beings—faceless with a palette of subtle or vibrant color that draws the viewer into the depth of the painting. As you have read through *Entertaining Angels*, I hope you got a glimpse of how angels (both real angels and the human kind) are woven into the daily routines of our lives.

I know there are so many more stories about angels out there in the world. If we were to open our eyes and our hearts, and tune our ears to hear, we would discover even more reports, enough to fill pages of hundreds of books—maybe *thousands*! I believe strongly in the heavenly realm and that God created these heavenly beings to guide, to protect, and to guard us in all our ways. God wants us to see His world that He created and loves so much, to see beyond what we *think* we see.

As an artist, I would like to think that God has given me a gift to share. As I listen to praise music and mix the scrumptious oil paints, allowing the Holy Spirit to move from the depths of my soul onto a blank canvas, I hope I am creating something that allows you to "see" the ethereal beings, and that they would speak to your soul and spark the mystery of God's creation. The ethereal beings I create are not to be worshiped, but rather, to point to Jesus who deserves all the praise.

One final note as we close this journey on *Entertaining Angels*: Whenever I sign my books, I always inscribe Psalm 91 under my name. I have been doing this since 2012 when my first book, *Angels in Our Midst*, was released. I always knew

the popular scripture—"For he will command his angels concerning you to guard you in all your ways" (Psalm 91:11)—but then I made a note one day to memorize the entire scripture, all *sixteen* verses.

A few weeks later, my husband and I were at a weekend retreat at the incredible Diamond Cross Ranch in Jackson Hole, Wyoming. We sat in a dusty arena on the ranch and witnessed a demonstration of "horse whispering." Now, if you had asked me a few days prior what that was, I would have had no idea. But witnessing it was *mesmerizing.*

The owner and horse whisperer, Grant, sat stately on his horse (one that had already been trained) before the demonstration began and shared his testimony. Weaving in bits and pieces of his life and relating it to horse taming, he said that for the past thirty-plus years, he and his wife would always say Psalm 91 out loud with each other. He looked over to his wife then and said, "Let's just say it now." They broke out in unison—no notes, no Bible—just glancing back and forth as they recited Psalm 91.

The powerful words echoed throughout the arena. It was my nudge from heaven.

Now, I invite you to do what I did: memorize all sixteen verses and let these living words surround you and your family. For convenience, I have shared the entire Psalm 91 here with you. Add it to your calendar on your phone with a daily reminder to pause and pray, and to claim God's Word and His promises over your life, your family's lives, your business, and anyone else you might be praying for.

God's angels are all around us, and God commands His angels to protect us in all our ways.

Whoever dwells in the shelter of the Most High

 will rest in the shadow of the Almighty.

I will say of the LORD, "He is my refuge and my fortress,

 my God, in whom I trust."

Surely he will save you

 from the fowler's snare

 and from the deadly pestilence.

He will cover you with his feathers,

 and under his wings you will find refuge;

 his faithfulness will be your shield and rampart.

You will not fear the terror of night,

 nor the arrow that flies by day,

nor the pestilence that stalks in the darkness,

 nor the plague that destroys at midday.

A thousand may fall at your side,

 ten thousand at your right hand,

 but it will not come near you.

You will only observe with your eyes

 and see the punishment of the wicked.

If you say, "The LORD is my refuge,"

 and you make the Most High your dwelling,

no harm will overtake you,

 no disaster will come near your tent.

For he will command his angels concerning you

 to guard you in all your ways;

they will lift you up in their hands,

 so that you will not strike your foot against a stone.

You will tread on the lion and the cobra;

 you will trample the great lion and the serpent.

"Because he loves me," says the LORD, "I will rescue him;

 I will protect him, for he acknowledges my name.

He will call on me, and I will answer him;

 I will be with him in trouble,

 I will deliver him and honor him.

With long life I will satisfy him

 and show him my salvation."

—PSALM 91

Acknowledgments

W riting a book takes a village! I could write a whole book about all the people who have come alongside to support, encourage, and cheer me along this path of publishing.

First and foremost, I thank our living Lord Jesus Christ who leads, equips, shapes, and molds me with the incredible desire to step out in faith and help others through my art, my devotionals, and my writings. I have been deeply touched by the many people He has put in my path to share testimonies, stories, and extraordinary God moments. I know that God surrounds His people with angels to protect and to guide, and I give Him the glory now and forever!

My precious husband, Clark, has been my rock and I am ever so grateful for his wit, humor, and steadfast love. Thank you for your support throughout the years as you have watched God guide me on this journey. It has been overwhelming at times and I am so thankful that together we can cling to the promise of God's Word: "I can do all things through Christ who gives me strength." You and our incredible four children—Blakely, Catherine, Taylor, and Ford—are my life. Your love, support, patience, and encouragement keep me going.

To my editor, publisher, and the entire team at HarperCollins Thomas Nelson, I give you the greatest praise of gratitude. Deadlines, meetings, meetings, and more deadlines—your team has surrounded me with such grace and vision, and I am ever so grateful to be a part of your family. We have had a beautiful partnership for these past three books, and I cannot wait to see all the other amazing things ahead.

When I say it takes a village, I really mean *a village*. To all the countless friends

who have surrounded me with prayer or called to say, "I am praying for you." To the dog walkers who have come on a day's notice to walk my new puppy so I could retreat to write or paint. To the staff at my gallery, Anne Neilson Fine Art, who stepped through the doors every day with a ray of sunshine and the most bubbly personalities I have ever witnessed. (If you have not been to the gallery in Charlotte, it needs to be a destination on your bucket list. You need to meet Logan and tour our beautiful gallery of over sixty artists, plus my studio, which can be a mess sometimes.) I could not have done this without your support, love, and drive.

And finally, my Anne Neilson Home team: You are amazing! Wendy and Sydnie, you wear many hats that shift and change daily, and each of you does it with such grace—and sometimes with *extra* grace. I am ever so grateful for you and know that God's angels surround you daily, and His best is yet to come for many things ahead. Stay steadfast and strong, clinging to His promises daily.

I am simply grateful. Thank you for making this journey with me and for your love and support!

Notes

1. Christine Caine, (@christinecaine), Twitter, December 28, 2014, https://twitter.com/christinecaine/status/549427531829764098?lang=en.
2. Mark Batterson, *Draw the Circle: The 40 Day Prayer Challenge*, Grand Rapids, MI: Zondervan, 2012.
3. Often attributed to Saint Francis of Assisi.

Contributors

Thank you to all of the wonderful and generous contributors for your inspiring and heartfelt stories. You can learn more about each contributor below.

Tracy Kornet

NBC anchor in Nashville, Tennessee

instagram.com/tkornet

Ron Hall

Art dealer, author, and producer

ronrhall.com

Jimmy Wayne

Country music singer and songwriter, and *New York Times* best-selling author

jimmywayne.com

Cheryl Scruggs

Author and host of *Thriving Beyond Belief* podcast

jeffandcherylscruggs.com

Susan Brown

Owner and founder of Grace 251

facebook.com/daltongrace251

Jamie Heard

Co-founder and executive director of Faithfully Restored

faithfullyrestoredwomen.com

Amy Carlisle

Wife, mother, and artist

amycarlisleart.com

@AmyCarlisleArt on Instagram

Jacob Paul Bright

Owner of Fine Things

@jacobpaulbright on Instagram

Sheila Walsh

Television host, author, and Bible teacher

sheilawalsh.com

Teresa Hucko

Author, equipper, and speaker

teresahucko.com

Anne Cochran

Wife, mother, author, and intercessor

Carol U. Gamble

Mother, worship and prayer warrior, and WholyFit instructor

wholyfit.org

Lisa Clark

Author, speaker, and host of *The Wonder Podcast*

linktr.ee/Lisaeclark

Gwen E. Smith

Host of the *Graceologie* podcast, coach, speaker, and author of

I Want It All and *Broken into Beautiful*

instagram.com/gwensmithmusic/

Christina Spillars Meadows

Owner of Quintessentials

shopquintessentials.com

Gigi Harris

Wife, mother of four, and community volunteer

Anne Ferrell Tata

Author and politician

teamtata.org

About the Author

A lifelong artist, Anne Neilson began painting with oils in 2003 and quickly became nationally renowned for her ethereal Angel Series. Neilson's paintings are inspiring reflections of her faith.

In 2012 Neilson self-published *Angels in Our Midst*, her first of three coffee-table books. Following its success, *Strokes of Compassion* and *Angels: The Collector's Edition* were released. The books follow her journey through the Angel Series, sharing inspirational and personal stories behind her paintings and the organizations she supports. Neilson also launched Anne Neilson Home—a growing collection of luxury home products, including candles, notecards, scripture cards, prints, and journals. Her latest book, published by Thomas Nelson, *Anne Neilson's Angels: Devotions and Art to Encourage, Refresh, and Inspire* sold more than fifty-thousand copies in the first two months. It explores forty words, each accompanied by an angel painting, a thoughtful definition, Scripture, prayers, and reflections from Anne's life.

Neilson also owns Anne Neilson Fine Art, a gallery located in Charlotte, North Carolina. Representing more than sixty talented artists from around the world, the gallery is dedicated to being a lighthouse, illuminating the work of both emerging and established artists.

As a wife, mother of four, artist, author, and philanthropist, Anne paints and creates with passion and purpose, always giving back to others by contributing to local, national, and international charitable organizations.

Learn more about Anne Neilson Home and her gallery, Anne Neilson Fine Art, at anneneilsonhome.com and anneneilsonfineart.com.